DATE DUE

BLACK
AUTHORS & ILLUSTRATORS
OF CHILDREN'S BOOKS

SECOND EDITION

GARLAND REFERENCE LIBRARY OF THE
HUMANITIES (VOL. 1316)

BLACK
AUTHORS & ILLUSTRATORS
OF CHILDREN'S BOOKS

SECOND EDITION

A Biographical Dictionary
Barbara Rollock

Garland Publishing • New York & London • 1992

Library of Congress Cataloging-in-Publication Data

Rollock, Barbara.
 Black authors and illustrators of children's books: a
biographical dictionary / Barbara Rollock.—2nd ed.
 p. cm.—(Garland reference library of the
 humanities: vol. 1316)
 Includes index.
 ISBN 0-8240-7078-X
 1. Children's literature—Black authors—Bio-bibliog-
raphy. 2. Children's literature. American—Afro-American
authors—Bio-bibliography. 3. Children's literature, Ameri-
can–Illustrations—Bio-bibliography. 4. Afro-American
authors–Biography—Dictionaries. 5. Afro-American artists—
Biography–Dictionaries. 6. Authors, Black—Biography—
Dictionaries. 7. Artists, Black–Biography–Dictionaries. 8.
Illustrators—Biography—Dictionaries.
 I. Title. II. Series.
 Z1037.R63 1992
 [PN1009.A1]
 809'.89282—dc20
 [B] 91-37402
 CIP

Cover & Book design by Marlon St. Patrick Mattis

Printed on acid-free, 250-year-life paper
Manufactured in the United States of America

TABLE OF CONTENTS

ACKNOWLEDGMENTS

Thanks and grateful acknowledgment is due several who helped track and trace authors and illustrators, many of whom were not always accessible or willing to communicate. Among the many helpers were librarians, booksellers, authors' agents, publishing staff, and a librarian at a Connecticut museum, the Wadsworth Atheneum in Hartford.

At the risk of missing some people I will mention a few: Sharon Howard, acquisitions librarian at the Schomburg Center for Research in Black Culture; Dr. Henrietta M. Smith, of the University of South Florida; Ginny Moore Kruse, director of the Cooperative Children's Book Center in Madison, Wisconsin; Flora Van Dyke, children's coordinator of the New Haven Public Library; and Angeline Moscatt, supervising librarian of the Central Children's Room in the New York Public Library.

Author Glennette Turner alerted me to people in the Midwest, and artists Pat Cummings and Cheryl Hanna offered information about those in their medium. Norma Jean Sawicki and staff at the publisher Orchard Books (particularly Allison Tulloch of Orchard Books), John Mason of Scholastic, Dawn Butcher of Holt, and Kathleen Fogarty of Random House were of great help as was Joannie Isaac, archivist at the Bernice Steinbaum Gallery. Booksellers Leothy Owens of Nkiru Books and Desmond Reid of D.A.R.E. Bookstore, both in Brooklyn, who let me browse through their new books for children on the black experience. Help came too from authors' agents Marie D. Brown of Brown Associates and Liza Pulitzer of Kirchoff & Wohlberg.

INTRODUCTION TO
THE FIRST EDITION

Prior to the 1960s the names of few black authors and illustrators of books for children were to be found in popular biographical sources or library reference books. Since then more names have appeared, with emphasis on the few who have achieved some prominence because of the volume of their published work or the awards they have received. Earlier citations featured only the same few well-known authors: James Weldon Johnson, Paul Laurence Dunbar, Langston Hughes, or Arna Bontemps. The fact that many more blacks in the United States and elsewhere have made contributions to children's literature was overlooked. Their works can provide an integral study of the black creative presence in children's books.

The books produced by those indigenous to a certain culture represent an important guide and resource in understanding the aspirations, thoughts, and viewpoints of that people. When books are neglected, both adults and children who need positive role models or awareness of a view other than the stereotypical one given by the media are deprived of a valuable insight into the true identity of a given group.

The biographical sketches included in this book of authors and illustrators are presented to acquaint all children with some creators of children's books. Their works have been published in the United States, they may live and work in this country, Africa, Canada, or Great Britain, and they happen to be black. Bibliographies are provided that include a selection of the author's or illustrator's works and may list some out-of-print titles by contemporary authors—many of these books have had short publication lives even though they may have represented a significant breakthrough at the time of their appearance. The works of authors

or illustrators now deceased are also included if they lived in the twentieth century, and particularly if their work has had some historical impact on the literature.

A few of the authors and illustrators in this book are listed even when they chose not to write on black themes or on the black experience. The criteria for selection does not exclude, for example, an illustrator like Donald Crews, whose graphic art form appeals to a general audience and is within the common everyday experience of all children. The only exclusions are those authors known primarily for adult books who have written only one book for children: James Baldwin's *Little Man, Little Man: A Story of Childhood* (Dial, 1977); Owen Dodson's *Boy at the Window* (Farrar, Straus, 1951; Reprint 1972); Pearl Bailey's *Duey's Tale* (Harcourt, 1975); and Katherine Dunham's *Kasamance: A Fantasy* (Third Press, 1974) come to mind. Bill Cosby's cartoon-like books about Fat Albert are also omitted in spite of their popularity.

On the other hand, those whose publications have not been widely popular are included because the writer or illustrator had some great impact on children's literature. Works with original subject matter and quality literary style that have been issued by trade publishers have been preferred for selection. Edited works of interest to children and textbook materials are often cited, as well as books for older children or young adults.

Some may argue that this dictionary isolates rather than integrates talented authors and illustrators. The intention is to provide those ill-informed or curious about the subject with a single reference volume in which the works of black authors and artists are recognized in relation to their particular contributions to children's literature.

The dictionary is arranged alphabetically by the author's and illustrator's surname. A selected bibliography appears at the end of each biographical sketch. Titles known to be out of print are followed by the abbreviation "o.p." Photographs of many of the artists are included. I hope that this dictionary will heighten

awareness of and perhaps foster an appreciation for those authors and illustrators little known to child readers.

The biographical sketches reveal a range and depth of competencies, backgrounds, and experiences these people have brought to their children's books. A total of 115 sketches are included. Though many more have written or produced books for children in this century, the task of personally contacting authors and artists or finding adequate material about them has limited the scope of the dictionary. At this point, however, the names selected and listed represent those black authors who have made or are making literary history in the world of children's books.

Barbara Rollock
May 1987

Introduction to The Second Edition

In the three years since the appearance of the first volume of *Black Authors and Illustrators of Children's Books*, publication of books for children has enjoyed a phenomenal boom. Along with the growing interest in children's literature has come a new emphasis on multicultural literature, and here books about African Americans and those of African descent have fared *almost* as well in publication since 1987 as they did in the 1970s. Significantly, they have involved more indigenous authors and illustrators.

In 1986 Walter Dean Myers spoke of the black community's need "to reinvest value in education and, specifically, in reading skills." If the proliferation of publishers, such as Just Us Books and Black Butterfly Press, and the bookstores specializing in materials on African Americans is any indication, this community is on its way to awareness of its cultural needs and the means for initiating and disseminating this information.

In three years, too, three authors and two artists whom we recognized in the first edition for their contribution to children's books, died: artist Romare Bearden and illustrator John Steptoe; authors John Kirkpatrick, Lorenz Graham, and Birago Diop, African writer and statesman. In this second volume, we have tried to include those who have brought something new to the field in the presentation of the culture. It is significant that this time also, people in pursuits other than writing for children have turned to creating for children. We acknowledged in the introduction to the first edition famous people who wrote only one or two books for children—performers Pearl Bailey and Bill Cosby, dancer Katherine Dunham, and writers James Baldwin and Owen Dodson. Among that group should have been listed TV newsman Bob Teague.

This year the author of note who is not included is Metropolitan Opera diva Leontyne Price, whose text for *Aida* is beautifully embellished by the art work of Leo and Diane Dillon. Actress Ruby Dee joins her husband among the authors that we have included in this volume. His plays are listed in the early volume. Her two books contain folktales.

We have tried to expand the scope of this edition with additional features: appendixes of publishers (a selection), bookstores and distributors, publishers' series, and award-winning books in the area of black experience. More than a third of the biographical sketches have been updated and more than 35 new authors/illustrators have been added, bringing the list of creators of children's books in this area to over 150. A title index lists approximately 500 titles. No attempt has been made to identify out-of-print titles this time since, happily, many have come back in print.

Some authors live in the Caribbean, Africa, England, or France, and for this reason little information was available from some of them. They seem to be a peripatetic lot. Within the last three years, African authors Chinua Achebe, Buchi Emecheta, and Efua Sutherland either have been lecturing or teaching in American colleges or have been doing their research here in the United States. Their American counterparts are equally busy traveling between bicoastal homes, teaching assignments, or changing personal commitments, all of which alter any permanent residence or surroundings. For this reason we have to rely on information about their movements from the publishers who produce their books.

With the onset of the economic downturn of 1991, book budgets may suffer, but this no doubt will be more than offset by the thrust to supply children with books about their own and other cultures, and the impact of the publication of these books within the past few years will be felt into the future.

Barbara Rollock
June 1991

FOREWORD

The second edition of *Black Authors and Illustrators of Children's Books* comes to us at a critical time in the evolution of parents' and educators' views of the role literature plays in the lives of children. Literature is fundamental to children's literacy and literary development, and it provides an excellent medium for children to explore, understand, and strengthen their identities. Literature also provides the means for children to reach out beyond their own world to explore the worlds of others. Multicultural literature plays a major role in the process of supporting self-awareness and an appreciation of cultural and ethnic diversity. Stories, poems, and illustrations by and about blacks make a particularly unique and important contribution. Their use has recently become even more significant because library-media specialists and classroom teachers increasingly rely on literature as a major curriculum resource.

In recent years, many educators have re-examined and restructured the ways in which they go about helping children learn to read and to write. The changes have occurred most often at the early childhood and elementary levels, but they are increasingly being used in the teaching of older students as well. Whether the changes appear under the headings of "holistic" or "process-oriented" approaches to literacy, the use of literature is a key component.

Trade or reference books of all kinds have found their way into every aspect of the school curriculum. Often they are used to complement traditional textbooks. In many cases they may replace them. At the same time that teachers are expanding their use of literature in the schools, there is an equally, if not more, important educational trend toward helping children develop an understanding and appreciation of different racial, cultural, and ethnic groups. As a consequence, the sharing of books by and about blacks has been placed at a high priority.

As the adults who live and work with children seek to make greater use of literature, their need for good resources increases. Many are unaware of how to acquire authoritative information about what literature is available and how to obtain it. *Black Authors and Illustrators of Children's Books* is just the kind of resource that is needed and wanted. In this excellent second edition Barbara Rollock has updated and expanded the entries included in the original volume and has substantially increased the number of entries. Of particular note are the appendixes featuring lists of bookstores and distributors of Afro-centric literature, award and honor books, series books and their publishers, and a list of publishers known for literature of this type.

No one is more knowledgeable about the black experience in children's literature than Barbara Rollock. Her many years as Coordinator of Children's Services for the New York Public Library and her deep and abiding interest in literature by and about blacks are undoubtedly what give this volume its obvious high quality. At a time when so many are attempting to help bring children and good literature together and when the sharing of literature is so naturally coupled with helping children deal with self-image and with diversity, it is hard to imagine a school or library without this fine resource.

Dorothy S. Strickland
State of New Jersey Professor of Reading

BIBLIOGRAPHICAL SOURCES AND REFERENCES

First Edition

Adams, Russell L. *Great Negroes Past and Present.* Illustrated by Eugene P. Ross, Jr. Third Edition. Chicago: Afro-American, 1981.

Colby, Vineta, ed. *World Authors, 1975–1980.* New York: Wilson, 1985.

Dictionary of Literary Biography: Afro-American Fiction Writers After 1955. Detroit: Gale, 1984.

Evory, Ann, ed. *Contemporary Authors: A Bio-Bibliographical Guide.* Detroit: Gale, 1982.

Herbeck, Donald E., ed. *Caribbean Writers: A Bio-Bibliographical–Critical Encyclopedia.* Washington, D.C.: Three Continents Press, 1977.

Kingman, Lee, Grace Allen Hogarth, and Harriet Quimby, eds. *Illustrators of Children's Books, 1967–76.* Boston: Horn Book, 1978.

Kirkpatrick, D. L., ed. *Twentieth-Century Children's Writers.* Preface by Naomi Lewis. Second Edition. New York: St. Martin's, 1983.

Klein, Leonard S., et al., eds. *Encyclopedia of World Literature in the 20th Century.* First Revised Edition. New York: Ungar, 1985.

Logan, Rayford U., and Michael R. Winston, eds. *Dictionary of American Negro Biography.* First Edition. New York: Norton, 1982.

Matney, William C., ed. *Who's Who Among Black Americans.* Fourth Edition. Lake Forest, Ill.: Educational Communications, 1985.

Meltzer, Milton, ed. *The Black Americans: A History in Their Own Words, 1619–1983.* New York: Crowell, 1984.

O'Brien, John, ed. *Interviews with Black Writers.* New York: Liveright, 1973.

Preiss, Byron, ed. *The Art of Leo and Diane Dillon.* New York: Ballantine, 1981.

Rush, Theresa Gunnels, ed. *Black American Writers Past and Present*. Metuchen, N.J.: Scarecrow Press, 1975.

Schockley, Ann Allen, and Sue P. Chandler, eds. *Living Black American Authors: A Biographical Directory*. New York: Bowker, 1973.

Ward, Martha, and Dorothy A. Marquardt, eds. *Authors of Books for Young People*. Supplement to the Second Edition. Metuchen, N.J.: Scarecrow Press, 1979.

Zell, Hans M., et al., eds. *A New Reader's Guide to African Literature*. New York: Africana, 1983.

Second Edition

Dance, Daryl C., ed. *Fifty Caribbean Writers: A Bio-Bibliographical Critical Sourcebook*. Westport, Conn.: Greenwood, 1986.

Evans, Mari, ed. *Black Women Writers, 1950–1980: A Critical Evaluation*. Garden City, N.Y.: Anchor/Doubleday, 1984.

Lloyd, Iris, and William C. Matney, Jr., eds. *Who's Who Among Black Americans, 1990–1991*. Sixth Edition. Foreword by Hon. Donovan J. Heith. Detroit: Gale, 1990.

Metzger, Linda, sr. ed., et al. *Black Writers: A Selection of Sketches from Contemporary Authors*. Detroit: Gale, 1989.

Mwalima, I., and L.C. Mwadilifu, eds. *Who's Who in African Heritage Book Publishing, 1989–1990*. Second Edition. Chesapeake, Va.: ECA Associates, 1989.

The New York Public Library. Office of Children's Services. *The Black Experience in Children's Literature*. New York: The New York Public Library, 1989.

The New York Public Library. Office of Young Adult Services. *Celebrating the Dream*. New York: The New York Public Library, 1990.

Page, James A., comp. *Selected Black American, African and Caribbean Authors: A Bio-Bibliography*. Littleton, Colo.: Libraries Unlimited, 1985.

Ploski, Harry A., and James Williams, comps. and eds. *The Negro Almanac. A Reference Work on the African American*. Fifth Edition. Detroit: Gale, 1989.

Vernoff, Edward, and Rima Shore. *The International Dictionary of 20th Century Biography*. New York: New American Library, 1987.

BLACK
AUTHORS & ILLUSTRATORS
OF CHILDREN'S BOOKS

ABDUL, RAOUL (1929–)
Author

The author/musician was born in Cleveland and attended the Academy of Music and Dramatic Arts in Vienna. He pursued additional studies at Harvard University in 1966. Besides giving lieder recitals in Austria, Germany, Holland, and the United States, he was a frequent guest on radio and television and appeared in operatic roles in the United States. He has lectured widely in the United States at the Performing Arts Center in Washington, D.C.; Lincoln Center for the Performing Arts in New York; the University of Connecticut; Howard University; and Columbia University.

Among his awards are the Harold Jackson Memorial Award, the Distinguished Service Award from the National Association of Negro Musicians, and a key to the city of Cleveland. He founded the Coffee Concert Series in Harlem and has served on the faculty of the Harlem School of the Arts. He was secretary and editorial assistant to the late Langston Hughes and is presently the music critic for the Amsterdam News.

Bibliography

The Magic of Black Poetry. Dodd, 1972.

Famous Black Entertainers of Today. Dodd, 1974.

Achebe, Chinua [Albert Chinualumogu] (1930–)
Author

Most of the English-speaking school children of Africa are familiar with the works of this Nigerian author, whose novels are often adapted for publication in secondary school texts. His narratives combine folk tale themes and traditional African proverbs and give glimpses of the cultural traditions unique to the Igbo people of Nigeria. Best known in the United States is his work *How the Leopard Got His Claws*. *The Drum*, also recognized in English-speaking countries, was originally written in Igbo and draws from a popular West African folk tale about a magic drum.

Achebe has held a variety of positions: teacher, editor, and university professor both in Nigeria and the United States. His publishing experience dates back to 1962 when he was founding editor of the Heinemann African Writers Series. He has also been director of Heinemann Educational Books in Nigeria and Naranife Publishers.

His awards include a Rockefeller Fellowship in 1960; a Nigerian Merit Award in 1979; the Commonwealth Poetry Prize in 1973; and doctorates in literature from Dartmouth College in 1972, the University of Nigeria in 1981, and the University of Kent in 1982. He was made an Honorary Member of the American Academy and Institute of Arts and Letters in 1982.

In 1984 Achebe was director of the Okike Arts Center, Nsukka, and was founder and publisher of Uwa Ndi Igbo, a bilingual journal of Igbo information and arts. In 1987 he won the Booker Prize for his work Anthills of the Savannah.

His office is at the Institute of African Studies, University of Nigeria, Nsukka.

Bibliography

How the Leopard Got His Claws with John Iroaganachi. Illustrated by Per Christiansen. Third Press, 1973.

The Drum. Illustrated by John Roper Eniga. Fourth Dimension, 1977.

AGARD, JOHN (1930–)
Author

John Agard is known as an actor, journalist, short story writer, and poet. He was born in Guyana, South America. He and his wife have contributed to the art scene of Guyana. His poetry has appeared in Expression, edited by Janice Lowe; Plexus, edited by R.C. McAndrew; and the Sunday Chronicle. Many of his short stories have been broadcast.

Besides works for adults, he has published five children's books. He now lives in England.

Bibliography

The Calypso Alphabet. Illustrated by Jennifer Bent. Holt, 1989.

Lend Me Your Wings. Illustrated by Adrienne Kennaway. Little, 1989.

Life Doesn't Frighten Me at All. Holt, 1990.

ARKHURST, JOYCE [COOPER] (1921–)
Author

> Spider Stories (or Anansi stories) are told up and down the coast of West Africa. They are told in many languages, but somehow the same plots recur over and over. When I went to Liberia, I wanted to capture their wit, and I hoped to put them down in a form American children would enjoy. Also, I wanted to create another chance for these funny, wise stories to cross the ocean, as they had done centuries ago when Africans coming to the New World brought them here. Then they changed magically and became the Anansi stories of the Caribbean and the Br'er Rabbit tales of the American South. Now children can recognize this heritage of past and present and enjoy it all.

Arkhurst is a librarian. Born in Seattle, she graduated from the University of Washington and Columbia University's School of Library Service. She has worked in the New York Public Library as a children's librarian and as a librarian in the New Lincoln School, New York City. She has also worked in Elizabeth Irvin High School in connection with the Little Red Schoolhouse, been a community coordinator in the Chicago Public Library, and developed a program at the Children's Neighborhood Center in Chicago.

As the wife of diplomat Frederick Arkhurst, former Ghana ambassador to the United Nations, she has traveled to Ethiopia, France, Ghana, and West Africa, where she collected many folk tales. She currently lives in New York and is employed in the New York City public school system.

Bibliography

The Adventures of Spider. Illustrated by Jerry Pinkney. Little, Brown, 1964.

More Adventures of Spider. Scholastic, 1971.

Baker, Augusta [Braxston]
(1911–)
Author

> John Kennedy said, "Children are the world's most valuable resource and its best hope for the future." It is my hope that the public library will recognize this statement and will give its best service to the children and will support the librarians who are giving their best to tomorrow's library users.

These words identify Baker's principal interest. Well known for her storytelling skills, Baker, a librarian, was educated at the State University of New York in Albany where she received her A.B. and B.S. in library science. Born in Baltimore, she began her library career in the New York Public Library in 1937. While working as a children's librarian in the 135th Street branch, she began the James Weldon Johnson Memorial Collection of Children's Books About Negro Life and its accompanying bibliography. The bibliography's title changed in 1971 to *The Black Experience in Children's Books.*

Although she spent thirty-seven years in the New York Public Library as a librarian—rising in the ranks from a branch children's librarian to coordinator of children's services—Baker was also a popular lecturer and adjunct faculty member at Columbia University, Rutgers University, and the University of Southern Nevada and a library consultant and organizer in Trinidad. Upon her retirement from the New York Public Library, she became storyteller-in-residence at the University of South Carolina in Columbia.

Among her many awards and honors are the first Dutton-Macrae Award in 1953 for advanced study in work with children; the *Parents* Magazine Medal in 1966 for outstanding service to the nation's children; the American Library Association's Grolier Award in 1968 for outstanding achievement in guiding and

stimulating children's reading; the Clarence Day Award in 1974; the Constance Lindsay Skinner Award in 1981 from the Women's National Book Association; the Regina Medal in 1981 from the Catholic Library Association; a Distinguished Alumni Award in 1975 from the State University of New York at Albany; and an honorary doctorate in 1980 from St. John's University.

Every April the University of South Carolina in Columbia observes "A Baker's Dozen," an occasion to celebrate storytelling and honor Augusta Baker at the same time.

Bibliography

The Young Years: Anthology of Children's Literature. Edited by Augusta Baker. Parents, 1950.

The Talking Tree. Lippincott,1955.

The Golden Lynx. Lippincott, 1960.

BARNETT, MONETA (1922–1976)
Illustrator

Barnett lived in Brooklyn and attended Cooper Union and the Brooklyn Museum Art School. The daughter of a tailor, Barnett, from 1966 until her death, illustrated at least one book a year.

Bibliography

My Brother Fine With Me by Lucille Clifton. Holt, 1970.

Fly Jimmy Fly! by Walter Dean Myers. Putnam, 1974.

Sister by Eloise Greenfield. Crowell, 1974.

Me and Neesie by Eloise Greenfield. Crowell, 1975.

Eliza's Daddy by Ianthe Thomas. Harcourt, 1976,

First Pink Light by Eloise Greenfield. Crowell, 1976.

BEARDEN, ROMARE H. (1914–1988)
Illustrator

Bearden was born in Charlotte, North Carolina, but grew up in New York and Pittsburgh. The distinguished painter exhibited no interest in drawing until high school. He earned his bachelor's degree in mathematics at New York University and later studied at the Art Students League, New York City, under teacher George Grosz. Bearden went to Paris to continue to study painting and in the 1960s began his collages on black themes. In 1977 the Museum of Modern Art in New York held a major exhibition of his work.

He was art director of the Harlem Cultural Council and a founder of Cinque Gallery in New York for beginning black artists.

Bibliography

Six Black Masters of American Art with Henry Henderson. Doubleday/Zenith, 1972.

Poems from Africa. Selected by Samuel Allen. Crowell, 1973,

A Visit to the Country by Herschel Johnson. Harper, 1989.

BENNETT, LERONE, JR. (1928–)
Author

Lerone Bennett, Jr., was born in Clarksdale, Mississippi, and attended public school in Jackson. He graduated from Morehouse College in 1949 with an A.B. degree followed by honorary degrees from Wilberforce University (doctor of humanities) in 1977, Morehouse College (doctor of letters) in 1965, and Marquette University in 1979.

Bennett started his career in journalism as a reporter in 1949 on the *Atlanta Daily World*. In 1952 he became the city editor of that newspaper. He became associate editor of *Jet* magazine in 1953; a year later, associate editor of *Ebony* magazine. He continued in that position through 1957, and in 1958 became senior editor of *Ebony*, the position he still holds.

He was visiting professor of history at Northwestern University in 1968–1969 and senior fellow at the Institute of the Black World in 1969.

In addition to his honorary degrees, Bennett was honored by the Windy City Press Club for outstanding magazine writing in 1965 and received the Capital Press Club's Journalism Achievement Award in 1963; the Patron Saints Award; the Society of Midland Authors Award for *What Manner of Man* in 1964; and the Literature Award, American Academy of Arts and Letters in 1978.

Bennett serves on the boards of trustees at Morehouse College; Martin Luther King, Jr., Memorial Center; WTTW; and Chicago Public Television. He is a member of the executive council of the Association for the Study of Afro-American Life and History and Phi Beta Kappa, among others. He has also served on the National Advisory Commission on Civil Disorders and attended the Second World Festival of Black and African Art in Nigeria as a delegate.

His books and short stories have been translated into French, German, Japanese, Swedish, Russian, and Arabic. He has traveled widely in Europe and Africa.

He is the son of Lerone Bennett, Sr., and Alma (Reed) Bennett. He is married to Gloria Sylvester and has four children: Joy, Constance, Courtney, and Lerone III.

Bibliography

What Manner of Man: A Biography of Martin Luther King, Jr. Johnson, 1964.

Before the Mayflower: A History of the Negro in America, 1619–1966. Revised Edition. Johnson, 1966.

Black Power, U.S.A.: The Human Side of Reconstruction, 1867–1877. Johnson, 1967.

Pioneers in Protest. Johnson, 1968.

Wade in the Water. Johnson, 1979.

BENT, JENNIFER
Illustrator

Bent was encouraged by her schoolmaster to study bookkeeping but she soon discovered that her abilities and certainly her preference lay in art.

She is especially interested in portraying traditional Caribbean folklore themes, and her work reflects her Jamaican roots. Even though her parents returned to Jamaica, she decided to stay in England because she felt more at home there.

In 1985, she finished Harrow Art College in England with a degree in illustration. She worked as a freelance artist until her work in children's book illustration. Her first book, *My Caribbean Home*, was published in England by Macdonalds and Co. She now lives in Watford, England.

She has expressed an awareness of the "lack of black artists" and hopes to add to the small number who might be in the field, even though, in her words, "I've never really encountered much prejudice."

Bibliography

The Calypso Alphabet by John Agard. Holt, 1981.

Tower to Heaven by Ruby Dee. Holt, 1991.

Berry, James
Author

Berry has had a distinguished career as a poet and writer since leaving his coastal village birthplace in Jamaica, West Indies. He has lived in England for over thirty years, involving himself in the social and cultural interests of the black community.

His interest in multicultural education has led to his conducting writers' workshops in schools, and in 1977–1978 he worked as writer-in-residence at Vauxhall Manor Comprehensive School in London. His publications include poems, short stories, magazine articles, and anthologies that have appeared in the United States, England, and the Caribbean nations.

He was awarded a C. Day Lewis Fellowship in 1977–1978.

Bibliography

A Thief in the Village and Other Stories. Orchard, 1988.

Spiderman Anancy. Illustrated by Joseph Glubo. Holt, 1989.

When I Dance by Karen Barbour. Harcourt, 1991.

BIBLE, CHARLES (1937–)
Author/Illustrator

The artist was born in Waco, Texas, and attended San Francisco State College in 1966–1967, Pratt Institute in 1969–1970, and Queens College of the City University of New York, where he earned his bachelor's degree in 1976. He worked for various printing and publishing concerns and was art director for the Jamerson Printing Company in San Francisco from 1952 to 1954, holding the same position in San Mateo at the Amistad Litho Company from 1963 to 1969.

He has had exhibitions in universities, galleries, and museums in New York and California, including the New Muse Community Museum in Brooklyn.

Bible served in the United States Navy from 1954 to 1956. His memberships include the National Conference of Artists, where he was a regional director from 1975 to 1976; the College Art Association; the American Institute for Graphic Arts; Council for Interracial Books for Children; and the Queens College of the City University of New York Veteran's Association.

Bibliography

Black Means . . . by Barney Grossman with Gladys Groom and the pupils of P.S. 150, the Bronx, New York. Hill and Wang, 1970.

Spin a Soft Black Song: Poems for Children by Nikki Giovanni. Hill and Wang, 1971.

Hamdaani: A Traditional Tale from Zanzibar. Holt, 1977.

Jennifer's New Chair. Holt, 1978.

BLAIR, CULVERSON (1947–)
Illustrator

Blair was born in Austin, Texas, and graduated from the University of Texas with a bachelor of fine arts in advertising art. His career has taken him from freelance illustration and design consultation for the American Cancer Society, *Black Enterprise* magazine, *House and Garden, Men's Wear* magazine, the *Village Voice, Ms.* magazine, and New Jersey Bell to special projects with the Nestle Company and the Macmillan Company, publishers, among others.

From 1973 to 1974 Blair was a lecturer in art at the University of Illinois, Urbana-Champaign, where he taught basic graphic design and letter form.

His work and illustrations have been published in many outstanding magazines, but his first work with children's books has been the *Afro-Bets* series.

Bibliography

Afro-Bets A B C Book by Cheryl Willis Hudson. Just Us Books, 1987.

Afro-Bets 1 2 3 Book by Cheryl Willis Hudson. Just Us Books, 1987.

BOND, JEAN CAREY
Author

Bond has lived in Ghana and, after graduating from Sarah Lawrence College, she worked for a state senator. She has contributed articles and book reviews to *Freedomways* magazine. She also worked during the late 1960s and 1970s as the editorial coordinator on the *Bulletin* of the Council on Interracial Books for Children, an organization that evaluated materials portraying biases or prejudices deemed harmful to young readers.

Bibliography

A Is for Africa. Watts, 1969.

Brown Is a Beautiful Color. Watts, 1969.

BONTEMPS, ARNA WENDELL (1902–1973)
Author

Arna Bontemps is considered to be one of the initiators of the Harlem Renaissance movement of the 1920s and 1930s. He was born in Alexandria, Louisiana, but his family moved while he was still very young to the West Coast, where he attended Los Angeles public schools. He studied at the University of Southern California and graduated with honors from Pacific Union College of California in 1923. In 1926 he won the *Crisis* Magazine Prize, the Alexander Pushkin Prize in 1926–1927, and a Rosenwald fellowship and Guggenheim fellowship for creative writing in 1949–1950.

His career spanned three decades. He was head librarian and publicity director at Fisk University, was a member of the Chicago Circle Campus's social service division at the University of Illinois in 1966, and served on the faculties of the University of Illinois and Yale University.

Bontemps was a close friend of Langston Hughes, his co-editor of the well-known anthology *Poetry of the Negro 1949–1970*.

Bibliography

Golden Slippers. Harper, 1941.

The Story of George Washington Carver. Grosset, 1954.

Lonesome Boy. Houghton, 1955.

American Negro Poetry. Edited by Arna Bontemps. Hill and Wang, 1963.

Hold Fast to Dreams: Poems Old and New. Selected by Arna Bontemps. Follett, 1969.

Mr. Kelso's Lion. Lippincott, 1970.

100 Years of Negro Freedom. Dodd, 1961. Revised Edition, Greenwood, 1980.

BOYD, CANDY DAWSON (1946–)
Author

Candy Dawson was born in Chicago, the oldest of three children. After her parents' divorce, she was raised by her mother, a school teacher. In the 1960s Boyd worked with Dr. Martin Luther King, Jr., as a field staff worker for the Southern Christian Leadership Conference.

She later taught school in Chicago and Berkeley and trained teachers and taught at Saint Mary's College of California. Boyd earned her bachelor's degree at Northeastern and Illinois State universities; her master's degree at the University of California, Berkeley, in 1978; and her Ph.D. in Education at Berkeley in 1982. Among her awards is an honorable mention for *Circle of Gold* given by the Coretta Scott King Award Committee in 1985.

Candy Dawson Boyd is married to Robert Boyd and lives in San Pablo, California. She is currently an associate professor at Saint Mary's College's Graduate Department of Education.

In 1986–1987, Boyd worked on the advisory committee for multiple subject credentials with an early childhood emphasis for the State of California Commission on Teacher Credentiality. She was also voted Outstanding Bay Area Woman by the Delta Sigma Theta sorority in 1986.

Bibliography

Circle of Gold. Scholastic, 1984.

Breadsticks and Blessing Places. Macmillan, 1985.

Charlie Pippin. Macmillan, 1987.

BRAWLEY, BENJAMIN (1882–1939)
Author

Brawley was born in Columbia, South Carolina, where his father, Edward McKnight Brawley, was pastor of a local Baptist church and a teacher at Benedict College. Benjamin Brawley attended schools in Nashville and Petersburg, Virginia. He later attended Morehouse College, where he received his first bachelor's degree. In 1907 he received a second A.B. from the University of Chicago and the following year a master's degree from Harvard University.

In 1913 he published *A Short History of the American Negro*; throughout 1916 he published books on English literature. His biography of poet Paul Laurence Dunbar is outstanding, and his *A Social History of the American Negro* is still highly acclaimed. In 1927 he declined the Harmon Foundation's second-place award for excellence in education.

Brawley was married to Hilda Damaris Prowd and died on February 1, 1939.

Bibliography

Paul Lawrence Dunbar: Poet of His People. University of North Carolina Press, 1936.

Negro Builders and Heroes. University of North Carolina Press, 1937 and 1965.

BREINBURG, PETRONELLA [BELLA ASHEY OR MARY TOTHAM] (1927–)
Author

Breinburg was born in Paramaribo, Suriname, South America. In 1965 she received a diploma in English from the City of London College. She attended Avery Mill Teachers College from 1969 to 1972 and Goldsmith College in London from 1972 to 1974. In Paramaribo she taught school but was also a factory worker, a postal clerk, and a nurses' aide. She worked as a volunteer for the Red Cross and Girls' Life Brigade in Suriname, lectured in creative writing, and was an outdoor storyteller in London. For about two years, starting in 1972, she taught English part time.

Her memberships include the Royal Society of Health, the Greenwich Playwright Circle, and the Poetry Circle. In 1962 she received an award from the Royal Society of Health and in 1972 was given an "honorary place" award from the Suriname Linguistic Bureau for her book *The Legend of Suriname*. Her picture book, *My Brother Sean* was a runner-up for the Library Association of London, Kate Greenaway Medal in 1974.

Bibliography

Shawn Goes to School. Illustrated by Errol Lloyd. Crowell, 1973.

Tiger, Tinker and Me. Macmillan, 1974.

Shawn's Red Bike. Illustrated by Errol Lloyd. Crowell, 1976.

BROOKS, GWENDOLYN (1917–)
Author

> My aim in my next future, is to write poems that will
> somehow successfully "call" . . . all black people: black
> people in taverns, black people in alleys, black people in
> gutters, schools, offices, factories, prisons, the consulate; I
> wish to teach black people in pulpits, black people in mines,
> on farms, on thrones. (From *Black Women Writers, 1950–
> 1980*. Edited by Mari Evans. Anchor/Doubleday, 1984.)

Pulitzer Prize winner Gwendolyn Brooks was born in Topeka and began writing verses at the age of seven. Her inspiration comes from poets James Weldon Johnson and Langston Hughes, whom she met in Chicago where she spent most of her childhood. Her first poem, *Eventide*, was published in *American Childhood*, a magazine for young people, when she was only thirteen. She started her own neighborhood newspaper, and by seventeen, she was a regular contributor to the *Chicago Defender*, where more than seventy-five of her poems and other writings appeared in its "Lights and Shadows" column.

In 1943 and 1944 Brooks won first prize for poetry from the Mid-West Writers' Conference and again in August 1945 for her book of verse, *A Street in Bronzeville*. She won the Pulitzer Prize in 1950, the first black to be so honored, for her second book *Annie Allen* and was named poet laureate of Illinois in 1977. She has lectured widely and taught at several colleges. She only wrote one book of poetry for children, *Bronzeville Boys and Girls*.

The poet became the twenty-ninth appointment as Consultant in Poetry to the Library of Congress in 1985. She is a member of the American Academy and Institute of Arts and Letters.

Brooks married the author of *Windy Place*, Henry Blakely, and they have a son and a daughter, Henry and Nora.

Bibliography

Bronzeville Boys and Girls. Illustrated by Ronni Solbert. Harper, 1956.

The Tiger Who Wore White Gloves. Illustrated by Timothy Jones. Third World, 1977.

BROWN, KAY (1932–)
Author

> My book is geared for a middle group, pre-adolescents. This is a critical age (11, 12, 13), yet most books published are either for young children or older teenagers. Few books in this category speak to the particular problems of young people in this age category; even less for this group as it relates to African American children.
>
> Specifically regarding *Willy's Summer Dream*, I try to tell the narrative from his point of view of the world. The reader feels Willy's anguish and frustration at being labeled, and the social isolation at being "different." Young people could identify with awkwardness and trauma of passing through such a period and would share the joy of Willy's small successes. It helps to point direction and offers hope.

Kay Brown is known primarily as an artist and printmaker. Her first novel—*Willy's Summer Dream*—for young adults has received critical acclaim.

She was born and raised in New York City. She graduated from the City College of New York, receiving her bachelor of arts degree in 1968, and from Howard University in Washington, D.C., where she earned a master of fine arts. In 1968 Brown became a member of the Weusi Artists and four years later co-founded the Where We At/Black Women Artists. She served as the organization's executive director for nine years. She has also been a professor at Medgar Evers College in Brooklyn.

Brown is also a member of the Afro-American Writers Guild in Washington, D.C., and the National Conference of Artists.

In 1983 she was awarded the Fanny Lou Hamer Award for Artistic Contribution to the Community in Brooklyn. Brown has two children.

Bibliography

Willy's Summer Dream. Gulliver/Harcourt, 1989.

BROWN, VIRGINIA SUGGS (1924–)
Author

Most of Brown's professional life has been spent as an elementary school teacher. She was teacher-in-charge of the Banneker Reading Clinic in the St. Louis public schools; an in-service teacher of remedial reading techniques at Harris Teachers College in St. Louis; a television teacher of reading for adults; a consultant in the Reading Institute College of the Virgin Islands, St. Thomas and St. Croix; and Director of Early Childhood Education, Webster Division, McGraw-Hill Book Company in 1966.

Brown has been a member of the International Reading Association; the Association for Childhood Education, International; and the National Association for the Education of Young Children. She received the National Council of Jewish Woman's Hannah G. Solomon Award for outstanding service to young children.

She is married to Charles F. Suggs and lived in St. Louis.

Bibliography

(Skyline Series)

Hidden Lookout. McGraw-Hill, 1965.

Watch Out for C. McGraw-Hill, 1965.

Who Cares? McGraw-Hill, 1965

Out Jumped Abraham. McGraw-Hill, 1967.

BRYAN, ASHLEY (1923–)
Author/Illustrator

"Un pont de doucer les relie" ("A tender bridge connects them") is the way Ashley Bryan thinks of the connection between his interest in African art, folklore, and music and his storyteller's skill in his children's books.

Bryan was born in New York and grew up in the Bronx, where he attended public schools. He went to Cooper Union and majored in philosophy at Columbia University.

He remembers starting to draw in kindergarten, illustrating books to give as gifts to childhood friends. In 1964 he illustrated *Moon, For What Do You Wait?*, poems from the Indian poet Tagore. It was the beginning of a long association with the Atheneum publishing house.

Bryan has taught school at Queens College of the City University of New York, Lafayette College, the Dalton School, and the Brooklyn Museum and has worked closely with Head Start and other community programs. His one semester at Dartmouth College as artist-in-residence resulted in his eventual appointment as a permanent faculty member and chairman of the art department.

He has illustrated several children's books as well as retold many folktales based on African, American or Caribbean lore. Among the many books he has illustrated, he especially prizes his volumes of spirituals.

Bryan has traveled to Africa, Europe, and Israel and has lived for a time in France and Germany. His art work has been exhibited in one-man shows and his interest in Afro-American poets is evident in his lectures and recitations. His *Walk Together Children* was a 1974 American Library Association (ALA) Notable Book and his *Beat the Story Drum, Pum-Pum* was a 1980 ALA Notable Book. In 1981 his illustrations for the latter won the Coretta Scott King Award.

He lives on a small island off the coast of Maine, where he makes puppets with beach objects.

Bibliography

Moon, For What Do You Wait? by Sir Rabindranath Tagore. Atheneum, 1964.

Ox of the Wonderful Horns and Other African Folktales. Atheneum, 1971.

Walk Together Children: Black American Spirituals. Volume One. Atheneum, 1971.

The Adventures of Aku. Atheneum, 1976,

The Dancing Granny. Atheneum, 1977.

I Greet the Dawn: Poems of Paul Laurence Dunbar. Atheneum, 1978.

Jethro and the Jumbie by Susan Cooper. Atheneum, 1979.

Jim Flying High by Mari Evans. Doubleday, 1979.

Beat the Story Drum, Pum-Pum. Atheneum, 1980.

I'm Going to Sing: Black American Spirituals. Volume Two. Atheneum, 1982.

The Cat's Purr. Atheneum, 1985.

Lion and the Ostrich Chicks and Other African Tales. Atheneum, 1986.

What a Morning! The Christmas Story in Black Spirituals. Selected and edited by John Langstaff. A Margaret K. McElderry Book/ Macmillan, 1987.

Turtle Knows Your Name. A Jean Karl Book. Atheneum, 1989.

All Night, All Day; A Child's First Book of African-American Spirituals. Music arrangements by David Manning Thomas. Atheneum, 1991.

Climbing Jacob's Ladder: Heroes of the Bible in African American Spirituals. Selected and edited by John Langstaff. A Margaret K. McElderry Book/Macmillan, 1991.

Burroughs, Margaret Taylor G. (1917–)
Author

Burroughs was born in St. Rose, Louisiana, and educated at Chicago Teachers College and the Art Institute of Chicago, where she received her bachelor's and master's degrees in education. She has taught in Chicago public schools, Kennedy King College, the Art Institute of Chicago and Elmhurst College. Burroughs is a founder of the National Conference of Artists and a founder of the DuSable Museum in Chicago. She is member of Phi Delta Kappa. She was awarded a fellowship from the National Endowment for Humanities and was an American Forum for African Study fellow in 1968.

Burroughs received the Senior Achievement Award in the Arts citation and the Women's Caucus for Art Award, Houston Museum of Fine Art, in 1988.

She is married to Charles Gordon and has two children.

Bibliography

Jasper the Drummin' Boy. Illustrated by Ted Lewin. Follett, Revised Edition, 1970.

Did You Feed My Cow? Illustrated by DeVelasco. Follett, 1956, 1969.

BYARD, CAROLE
Illustrator

Carole Byard was born in Atlantic City, New Jersey, studied at the Fleisher Art Memorial in Philadelphia, and graduated from the New York Phoenix School of Design. Her paintings are well known, and she has also done illustrations for magazines, film strips, and advertisements. She taught at the New York League of Girls and Women and the New York Phoenix School of Design. Her exhibitions and one-woman shows have won several prizes. She now lives in New York.

Bibliography

Under Chistopher's Hat by Dorothy M. Callahan. Scribner, 1972.

Africa Dream by Eloise Greenfield. Day, 1977.

I Can Do It By Myself by Lessie Jones Little and Eloise Greenfield. Crowell, 1978.

Cornrows by Camile Yarborough. Coward, 1979.

Three African Tales by Adjai Robinson. Putnam, 1979.

Grandmama's Joy by Eloise Greenfield. Collins, 1980.

The Black Snowman by Phil Mendez. Scholastic, 1989.

Have a Happy . . . by Mildred Pitts Walter. Lothrop, 1989.

CAINES, JEANNETTE FRANKLIN (1938–)
Author

Caines grew up in Harlem. She has been active in organizations such as the Salvation Army, where she served on the board of directors. She is also a member of the Negro Business and Professional Women of Nassau County and a councilwoman of the Christ Lutheran Church, Nassau County. She lives on Long Island (New York) with her husband and two children and was employed at a major publishing house in New York City.

Bibliography

Abby. Illustrated by Steven Kellogg. Harper, 1973. Reprint, Trophy, 1984.

Daddy. Illustrated by Ronald Himler. Harper, 1977.

Window Wishing. Illustrated by Kevin Brooks. Harper, 1981.

Just Us Women. Illustrated by Pat Cummings. Harper, 1982. Reprint, Trophy, 1984.

Chilly Stomach. Illustrated by Pat Cummings. Harper, 1986

I Need a Lunch Box. Illustrated by Pat Cummings. Harper, 1988.

CAMPBELL, BARBARA (1929–)
Author

Campbell was born in Arkansas and lived in St. Louis as a child. She earned her bachelor's degree at the University of California in Los Angeles.

She was a reporter for the *New York Times* city beat, the first black hired for the reporter-trainee program, and was then promoted to the reporting staff. She worked at *Life* magazine for two years and at the *New York Times* for thirteen years. In 1969 she was nominated for the Pulitzer Prize for articles on narcotics, civic issues, welfare conditions, civil rights, the poor, blacks, children, and older citizens.

Campbell currently lives in Greenwich Village, New York City, with her sons Jonathan and Zachary.

Bibliography

A Girl Called Bob & A Horse Named Yoki. Dial, 1982.

CAREW, JAN RYNVELD [JAN ALWYN CAREW] (1925–)
Author

Most of this author's works are known for their theme: the search for roots. Carew was born in Agricola, Guyana, and has been a professor and chairman of the Department of African American Studies at Northwestern University. He was a senior lecturer in the Council of Humanities and in the Department of Afro-American Studies at Princeton University. From 1966 to 1969 he lived in Toronto and edited *Cotopax*, a review of third-world literature.

In 1969 he was awarded a fellowship from the Canada Arts Council. Carew was editor of *De Kim* in Amsterdam, the *Kensington Post* in London, and the *African Review* in Ghana. In 1974 he won a certificate of excellecne from the American Institute of Graphic Arts for *The Third Gift*. In 1975 he set up the Jan Carew Annual Lecturship at Princeton. That same year he won the Burton Annual Fellowship from Howard University's Graduate School of Education. He lives in the Caribbean.

Bibliography

Rope the Sun. Third Press, 1973.

The Third Gift. Illustrated by Leo and Diane Dillon. Little, Brown, 1974.

The Twins of Ilora. Little, Brown, 1977.

Children of the Sun. Little, Brown, 1978.

CARTER, MARY KENNEDY (1934–)
Author

Carter was born in Franklin, Ohio, and graduated from Ohio State University. She received a master's degree from Columbia University and also attended London University and Makerere University in Kampala, Uganda. She was an elementary school teacher in the Cleveland public school system, a tutor and supervisor of teachers for the Uganda Ministry of Education, a research assistant at Teachers College at Columbia University, and a teacher of black studies in the Roosevelt, New York, school district. Other teaching assignments have included her work as professor at the United States Merchant Marine Academy in 1979; as a school consultant for the Baldwin, New York, schools; and as a curriculum writer in the Rockville Centre, New York, schools from 1983 to the present.

Carter's memberships include the National Council for Social Studies, the National Education Association, the Baldwin Educational Assembly (where she served as member and board member until 1984), and the Jack and Jill Association of America. She was awarded the Afro-American Fellowship in 1963. She is married to Donald Wesley Carter and lives in Freeport, New York.

Bibliography

Count On Me. American Book, 1970.

On to Freedom. Hill and Wang, 1970.

■————————————————————————

CARTEY, WILFRED (1931–)
Author

Born in Port-of-Spain, Trinidad, Cartey earned his bachelor's degree from the University of the West Indies in Jamaica and his master's in fine arts and doctorate from Columbia University.

He has received a Fulbright Travel Grant, a Bernard Van Ler Foundation Fellowship, and a Columbia University Travel and Research Grant.

Cartey was distinguished professor of black studies at City College in New York in 1973; professor of Afro-American Studies at the University of California, Berkeley, in 1974; and resident professor at the Extra-Mural Department, University of the West Indies.

He has been a consultant in African and Afro-American Studies and has held the Distinguished Professorship Martin Luther King Chair at City University of New York.

In 1985 and 1986 Cartey received a grant from the Research Foundation of the City University of New York.

Bibliography

The West Indies: Islands in the Sun. Nelson, 1967.

CARTY, LEO (1931–)
Illustrator

When Carty was eleven years old, he won a scholarship to the Museum of Modern Art School in New York City. He subsequently studied at Cooper Union, Pratt Institute, and the School of Visual Arts. He lives in Brooklyn with his wife and two children.

Bibliography

Where Does the Day Go? by Walter Dean Myers. Parents, 1969.

The House on the Mountain by Eleanor Clymer. Dutton, 1971.

I Love Gram by Ruth A. Sonneborn. Viking, 1971.

CHESNUTT, CHARLES WADDELL (1858–1932)
Author

Chesnutt was born in Cleveland. His parents were freemen who met on their flight north from North Carolina. Young Chesnutt became proficient in reading German, Latin, and French and in law, mathematics, and legal stenography. These studies added to his competency when he became a teacher.

He was a teacher-administrator, principal of the State Normal School in North Carolina, stenographer, journalist, lawyer, and short story writer for the MacClure syndicate and other periodicals. His first published story appeared in a Fayetteville, North Carolina newspaper. In 1899 his now famous *The Conjure Woman*, a work for adults, appeared.

In 1928 he received the Spingarn Medal from the NAACP for his "pioneer work as a literary artist depicting the life and struggles of the Americans of Negro descent, and for his long and useful career as scholar, worker, and freeman."

Bibliography

Conjure Tales. Retold by Ray Anthony Shepard. Dutton, 1973.

CHILDRESS, ALICE (1920–)
Author

> Early writing was done almost against my will, Grand-mother Eliza gently urged, "Why not write that thought down on piece a paper? It's worth keeping." Writing was jotting things down. The bits and pieces became stories. Writing was a way of reminding myself to go on with thoughts, to take the next step. Jottings became forms after I discovered the public library and attempted to read two books a day . . .
>
> My books tend to read somewhat like plays because theater heavily influenced my writing. I think mainly in terms of visual, staged scenes and live actors in performance—even in a novel. (From *Black Women Writers, 1950–1980*. Edited by Mari Evans. Anchor/Doubleday, 1984.)

Childress is an actress and writer who puts her theatrical experiences to good use in her books. Her plays for adults have won considerable acclaim: *Trouble in Mind* was awarded an Obie for the best Off-Broadway production in 1955–1956. She has been an actress and director in New York's American Theatre and is a member of the Harlem Writers Guild and New Dramatists. Many of her articles have appeared in *Freedomways, Black World*, and *Essence* magazines.

She was born in Charleston, North Carolina, and grew up and attended school in Harlem. In 1966 she received a Harvard appointment for independent study at Radcliffe Institute. Her work has involved extensive travel through Europe, the USSR, and China.

Her book *Rainbow Jordan* was cited for Outstanding Book of the Year in *School Library Journal* and in the *New York Times* in 1982. It was also a Notable Children's Trade Book in Social Studies and a Children's Book Council choice as well as an Honor Book for the Coretta Scott King Award.

She is married to film editor Nathan Woodard and makes her home in New York City.

Bibliography

A Hero Ain't Nothin' but a Sandwich. Coward, 1973.

When the Rattle Snake Sounds. Coward, 1975.

Let's Hear It for the Queen. Coward, 1976.

Rainbow Jordan. Coward, 1982.

Those Other People. Putnam, 1986.

CLAY, WIL (1938-)
Illustrator

Clay was born in Bessemer, Alabama, and started his commercial art career at Macomber Vocational High School in Toledo, Ohio. He also attended the American Academy of Art in Chicago from 1956 to 1957. Greatly encouraged by well-known Toledo artist Ernest Spring to pursue an art career, Clay received further training at the Vesper George School of Art in Boston in 1959–1960 and is currently enrolled at the University of Toledo.

In 1963 he opened his first studio in Providence, Rhode Island, and specialized in corporate design. He moved to Houston, Texas, where he set up a graphic design firm, remaining there until about 1975. By 1989 he was back in Toledo, where he currently works and teaches in his studio located at Common Space.

His collaboration with Constancia Gaffeney-Brown resulted in his winning the international competition sponsored by the Arts Commission of Greater Toledo to honor Dr. Martin Luther King, Jr. His sculpture "Radiance," a six-foot bronze and stainless steel work of King, features modeled heads of King on a polished steel sphere. The work was dedicated in downtown Toledo in September 1980.

In 1990 he visited Cameroon for six months as part of his studies in art history and sculpture at the University of Toledo. While in Africa he worked with the Bamileke people and the Fulani, studying their art in beadwork, painting, woodworking, and the like in relation to their folkways and tribal lifestyles.

The illustrations for his first children's book, *Tailypo*, were inspired by childhood memories of visits to his two grandmothers, both of whom lived in rural Alabama. Jan Wahl, who retells the folktale, discovered the "sense of the comic" he wanted for the book's illustrations when he visited Clay's Toledo studio.

Clay's art can be found in private collections not only in the United States—in California, Colorado, Il-

linois, Michigan, Rhode Island, Massachusetts, and Washington, D.C.—but also in Canada, Sierra Leone, and Cameroon.

Clay is the father of two sons and four daughters, and resides in Perrysburg, Ohio.

Bibliography

Tailypo. Retold by Jan Wahl. Holt, 1991.

213 Valentines by Barbara Cohen. Holt, 1991.

CLIFTON, LUCILLE [THELMA SAYLES] (1936–)
Author

> I am a woman and I write from that experience. I am a Black woman and I write from that experience. I do not feel inhibited or bound by what I am. . . .
>
> I have been a wife for over twenty years. We have parented six children. Both these things have brought me great joy. I try to transmit the possible joy in my work. This does not mean that there have been no dark days; it means that they have not mattered. In the long run, I try to write about looking at the long run. (From *Black Women Writers, 1950–1980*. Edited by Mari Evans. Anchor/Doubleday, 1984.)

Clifton was born in Depew, New York, and attended Howard University and Fredonia State Teachers College, where she made friends with a small group of blacks interested in theater. She met Ishmael Reed there; he showed her poems to Langston Hughes, who published some in his anthology, *Poetry of the Negro*. There she also met her husband, Fred Clifton, another member of the group. He was a writer, artist, and philosophy teacher at the University of Buffalo. They married in 1958 and became the parents of six children.

Clifton received the Discovery Award from the YW-YMHA Poetry Center in New York in 1969. *Some of the Days of Everett Anderson* was her first book of poems for children. She received grants from the National Endowment for the Arts from 1969 to 1972. She was poet-in-residence at Coppin State College in Baltimore, a visiting writer at Columbia University School of the Arts, and poet laureate of Maryland from 1979 to 1982.

Since the death of her husband she has made her home in California and Maryland, where she maintains an active teaching and lecturing career.

Bibliography

The Black BC's. Illustrated by Don Miller. Dutton, 1970.

Some of the Days of Everett Anderson. Illustrated by Evaline Ness. Holt, 1970.

All Us Come Cross the Water. Illustrated by John Steptoe. Holt, 1973.

The Boy Who Didn't Believe in Spring. Illustrated by Brington Turkle. Dutton, 1973.

Don't You Remember? Illustrated by Evaline Ness. Holt, 1973.

The Times They Used To Be. Illustrated by Susan Jeschke. Holt, 1974.

Everett Anderson's Friend. Illustrated by Ann Grifalconi. Holt, 1976.

The Lucky Stone. Illustrated by Dale Payson. Delacorte, 1979.

Everett Anderson's Goodbye. Illustrated by Ann Grifalconi. Holt, 1983.

Everett Anderson's Christmas Coming. Illustrated by Jan Spivey Gilchrist. Holt, 1991.

Three Wishes. Illustrated by Michael Hays. Delacorte, 1992.

Cooper, II, Floyd Donald (1956–)
Illustrator

Cooper states that he hopes his work will "produce books about blacks for white kids. One of the more satisfying rewards for my work comes when I get the opportunity to do a book about the black experience to broaden and enlighten someone who may not be aware."

Cooper was born in Tulsa, Oklahoma. A graduate of Tulsa Central High School, he earned a bachelor of fine arts from the University of Oklahoma at Norman. Children's book illustration initially was a way to complement his work in advertising. While at the university, he studied under Mark English and after graduation worked with a greeting card company in Missouri.

After moving to the eastern part of the country, he discovered the diversity and creativity he sought in children's book illustration in 1984. His first book, *Grandpa's Face*, was an American Library Association Notable Book. He has received recognition from the Society of Illustrators and exhibited at "The One Show."

Cooper currently resides in East Orange, New Jersey. He has one son.

Bibliography

Grandpa's Face by Eloise Greenfield. Philomel/Putnam, 1986.

Chita's Christmas Tree by Elizabeth Howard. Bradbury 1989.

Laura Charlotte by Karen Osebold Galbraith. Philomel, 1990.

Martin Luther King, Jr. by Della Rowland. Silver Burdett, 1990.

When Africa Was Home by Karen Lynn Williams. Orchard, 1990.

Martin Luther King, Jr., and His Birthday by Jacqueline Woodson. Silver, 1990.

CORNISH, SAM (1935–)
Author

The author grew up in Baltimore and attended Douglass High School, which he left after his first semester. He was in the Medical Corps of the United States Army from 1958 to 1960 and later attended Goddard College in Vermont. Cornish worked in various places, from an insurance company to bookstores, and later became a consultant on children's writing for the Educational Development Center, Newton, Massachusetts, in their Open Education Follow-Through Project.

Bibliography

Your Hand in Mine. Harcourt, 1970.

Grandmother's Pictures. Illustrated by Jeanne Johns. Bradbury, 1976.

CREWS, DONALD (1938-)
Illustrator

Crews was born in Newark and attended Arts High School, where admission for music and art training is by competitive examination. He also attended Cooper Union in New York City. He served two years of military service in Germany, where he married Ann Jonas, a fellow student from Cooper Union. They have two daughters.

Freight Train (1979) and *Truck* (1981) were Caldecott Honor books. *Freight Train* was also an American Library Association Notable Book and a Junior Literary Guild choice along with *Truck and Carousel*. In 1979 the American Institute of Graphic Arts Children's Book Show exhibited *Rain* and *Freight Train*. The artist's work has also appeared in *Graphis* magazine.

Bibliography

Freight Train. Greenwillow, 1978.

Rain. Greenwillow, 1978.

Truck. Greenwillow, 1980.

Light. Greenwillow, 1981.

Carousel. Greenwillow, 1982.

Harbor. Greenwillow, 1982.

Parade. Greenwillow, 1983.

School Bus. Greenwillow, 1984.

We Read: A to Z. Greenwillow, 1984.

Bicycle Race. Greenwillow, 1985.

How Many Snails? A Counting Book by Paul Gigante, Jr. Greenwillow, 1990.

Bigmama's. Greenwillow, 1991.

CRICHLOW, ERNEST (1914-)
Illustrator

The artist remembers loving to draw since grade school days, when he drew from models suggested by his teacher. After his graduation from Haaren High School in New York, some of his art teachers arranged for his scholarship at Commercial Illustration School of Art and raised money for his art supplies.

His collaboration with Lorraine and Jerrold Beim on *Two Is a Team*, an easy book about the interracial friendship of two little boys, was the beginning of a successful career in children's book illustration generally on black themes. His art work has been exhibited in many art shows. He has taught at Shaw University, State University of New York at New Paltz, City College of New York, and the Brooklyn Museum Art School.

With N. Lewis and Romare H. Bearden he founded the Cinque Gallery and co-directs a group of black artists at Saratoga, New York, under the aegis of the State Education Department of Arts and Humanities. Crichlow is also a member of the Black Academy of Arts and Letters.

Crichlow is married and has one son. He and his family live in Brooklyn.

Bibliography

Two Is a Team by Lorraine and Jerrold Beim. Harcourt, 1945.

Mary Jane by Dorothy Sterling. Scholastic, 1959.

Forever Free by Dorothy Sterling. Doubleday, 1963.

Freedom Train: The Story of Harriet Tubman by Dorothy Sterling. Doubleday, 1963.

Lift Every Voice by Dorothy Sterling and Benjamin Quarles. Doubleday, 1964.

The Magic Mirrors by Judith Griffin. Coward, 1971.

CULLEN, COUNTEE [PORTER]
(1903–1946)
Author

The scholarly Cullen was among the most respected poets to emerge from the Harlem Renaissance of the 1920s–1930s. He was adopted by Rev. and Mrs. Frederick A. Cullen. Young Countee was an outstanding student at De Witt Clinton High School, at the time one of the best secondary schools in New York. He was vice-president of his graduating senior class, editor of the *Clinton News*, and chairman and editor of the senior edition of the school's literary magazine, *The Magpie*. He was also treasurer of the Inter-High School Poetry Society. Cullen was a member of the school's honor society and Arista, and he graduated with honors in at least five subjects: Latin, English, French, history, and mathematics.

Cullen began writing poetry as a child. In high school he won a second prize for the poem "In Memory of Lincoln" and a contest prize for his well-know "I Have a Rendezvous with Life." He attended New York University, was elected to Phi Beta Kappa—one of a few to receive the honor in 1925 from that college—and in the same year won the Witter Bynner undergraduate poetry contest and second prize in the *Opportunity* literary contest—second only to Langston Hughes.

His first collection of poems, *Color* (an adult work, Harper & Brothers, 1925), won the Harmon Foundations' Award for Literature, awarded by the NAACP for "distinguished achievement in literature by a Negro." He received his master's degree in English from Harvard University in 1926 and was assistant editor of *Opportunity, A Journal of Negro Life*, in which his monthly column, "The Dark Tower," appeared.

Bibliography

The Lost Zoo. Follett, 1949.

CUMMINGS, PAT MARIE (1950–)
Illustrator

Pat Cummings was born in Chicago. As part of an army family, Cummings spent her childhood in many places in and out of the United States. She received her bachelor's degree from Pratt Institute in 1974.

In 1974 she became a freelance illustrator and is currently a professor of design at Queensborough Community College in New York City. She is a board member of the Black Art Directors' group in New York and a member of the Graphic Artist Guild.

In 1984 Cummings' illustrations for *My Mama Needs Me* won the Coretta Scott King Award, and in 1983 her illustrations for *Just Us Women* merited an honorable mention. She also received the CEBA award for an illustration advertising Con Edison and an honorable mention in 1978 for a poster for the United Nations Committee on Apartheid.

Cummings is married to Chucku Emeka Lee. They live in Brooklyn.

Bibliography

Good News by Eloise Greenfield. Coward, 1977.

Just Us Women by Jeannette Caines. Harper, 1982.

My Mama Needs Me by Mildred Pitts Walter. Lothrop, 1983.

Chilly Stomach by Jeannette Caines. Harper, 1986.

C.L.O.U.D.S. Lothrop, 1986.

Springtime Bears by Cathy Warren. Lothrop, 1987.

I Need a Lunch Box by Jeannette Caines. Harper, 1988.

Storm in the Night by Mary Stoltz. Harper Trophy, 1988.

Willie's Not the Hugging Kind by Joyce Durham Barrett. Harper, 1989.

Two and Too Much by Mildred Pitts Walter. Bradbury, 1990.

Clean Your Room, Harvey Moon. Bradbury, 1991.

Go Fish by Mary Stoltz. HarperCollins, 1991.

Talking with Artists. Bradbury, 1992.

DAVIS, OSSIE (1917–)
Author

Davis, an actor, playwright, and director was born in Cogdell, Georgia. He has held a variety of jobs. He served as a surgical technician in the United States Army's Special Services during World War II from 1942 to 1945. He has acted on stage, screen, and television. He and his actress wife Ruby Dee appeared on Howard University's WBBM-TV's "In Other Words . . . Ossie and Ruby." He did a production of *Bingo* at an AMAS Repertory Theatre.

His children's books are plays based on major figures in black history: Frederick Douglass and Langston Hughes.

Davis is married to Ruby Ann Wallace (Ruby Dee). They have three children: Nora, Guy, and LaVerne. They live in New Rochelle, New York. [*See also* Dee, Ruby.]

Bibliography

Escape to Freedom: A Play About Young Frederick Douglass. Viking, 1978.

Langston, A Play. Delacorte, 1982.

DEE, RUBY [RUBY ANN WALLACE]
(1923–)
Author

Ruby Dee's purpose in writing is to "create exciting and challenging reading for children—to inform the senses and entertain."

Dee is primarily known as an actress, but she has also published books. She wrote poetry before venturing into the children's book world.

She was born in Cleveland, Ohio, and is married to actor-playwright Ossie Davis, who has written plays for children as well as adults. They are the parents of a son and two daughters.

Dee received her bachelor of arts degree from Hunter College in New York and in the 1950s attended actors' workshops at Fairfield University, Iona College, and Virginia State College. She has been active as an actress in films, actress and writer in the American Negro Theatre, the co-host of the radio program "Ossie Davis and Ruby Dee Story Hour" from 1974 to 1978, and on PBS television "With Ossie and Ruby" in 1981.

The actress has made recordings for Caedmon, Folkways, and Newbery records that won various awards. A civil rights activist, Dee is a member of the NAACP, Negro American Labor Council, Southern Christian Leadership Conference, and Students for Non-Violence Coordinating Committee. A member of the American Federation of Television and Radio Artists, she has won an Emmy from the Academy of Television Arts and Sciences for a single performance in 1964 in "Express Stop from Lenox Avenue." With Davis, she received the Frederick Douglass Award from the New York Urban League for their work in the play *Boseman and Lena*; the Martin Luther King, Jr., Award from Operation PUSH in 1977; and the Drama Desk Award in 1974. She is enrolled in the Hunter College

Hall of Fame and received the college's President's Medal. [*See also* Ossie Davis.]

Bibliography

Two Ways to Count to Ten. Illustrated by Susan Meddaugh. Holt, 1988.

Tower to Heaven. Illustrated by Jennifer Bent. Holt, 1991.

DEVEAUX, ALEXIS (1948–)
Author

Deveaux, recognized as a poet, novelist, and play-wright, was born and raised in New York. Her many theater workshops, appearances on radio and television talk shows, and poetry readings have popularized her work. She has taught creative writing; wrote a novel, *Spirits in the Street;* and wrote a biographical prose poem, *Don't Explain: A Song for Billie Holiday.* She worked for the Urban League, taught for the Neighborhood Youth Corps, and was the poetry editor of *Essence* magazine. Her plays—*Circles, Tapestry,* and *A Season to Unravel,* which was performed by the Negro Ensemble Company in New York in 1979—display her interest in the theater.

Bibliography

na-ni. Harper, 1973.

Don't Explain: A Song for Billie Holiday. Harper, 1980.

An Enchanted Hair Tale. Illustrated by Cheryl Hanna. Harper, 1987.

DILLON, LEO (1933–)
Illustrator

Born in Brooklyn, Leo Dillon attended AIGA Workshop, Parsons School of Design, and the School of Visual Arts, all in New York City. He and his wife Diane work as a team; they met at Parsons and married shortly after graduation. They have illustrated book jackets, magazines such as *The Ladies Home Journal*, posters, and children's books.

Their books have won many honors and awards. *Song of the Boat* won the Boston and Globe Horn Book Honor Award for illustrations. Their Caldecott-winning books—*Why Mosquitoes Buzz in People's Ears* and *Ashanti to Zulu: African Traditions*—are only two of the widely acclaimed books they have embellished.

Leo and Diane Dillon have one son, Lee, and live in Brooklyn.

Bibliography

Behind the Back of the Mountain: Black Folktales from Southern Africa. Retold by Verna Aardema. Illustrated by Leo and Diane Dillon. Dial, 1973.

Songs and Stories from Uganda by W. Moses Serwadda. Illustrated by Leo and Diane Dillon. Crowell, 1974.

The Third Gift by Jan Carew. Little, Brown, 1974.

Why Mosquitoes Buzz in People's Ears. Retold by Verna Aardema. Illustrated by Leo and Diane Dillon. Dial, 1975.

The Hundred Penny Box by Sharon Bell Mathis. Illustrated by Leo and Diane Dillon. Viking, 1975.

Ashanti to Zulu: African Traditions by Margaret Musgrove. Illustrated by Leo and Diane Dillon. Dial, 1976.

Honey I Love by Eloise Greenfield. Illustrated by Leo and Diane Dillon. Crowell, 1978.

Listen, Children: Anthology of Black Literature. Edited by Dorothy Strickland. Illustrated by Leo and Diane Dillon. Bantam, 1982.

The People Could Fly by Virginia Hamilton. Illustrated by Leo and Diane Dillon. Knopf, 1985.

Moses' Ark: Stories from the Bible by Alice Back and J. Cheryl Exum. Delacorte, 1989.

Aida by Leotyne Price. Illustrated by Leo and Diane Dillon. Gulliver, 1990.

Alaskan Lullaby by Nancy Carlson. Illustrated by Leo and Diane Dillon. Dial, 1990.

The Race of the Golden Apples. by Claire Martin. Illustrated by Leo and Diane Dillon. Dial, 1990.

Tale of the Mandarin Ducks by Katherine Paterson. Illustrated by Leo and Diane Dillon. Lodestar/Dutton, 1990.

Pish, Posh, Said Hieronymus Bosch by Nancy Willard. Illustrated by Leo and Diane Dillon. Dial, 1991.

Diop, Birago (1906–1989)
Author

This son of a Wolof father was born in Ouakam, a suburb of Dakar, Senegal. He went to school in Rue Thiong, Dakar, and later won a scholarship to Lycee Faidherbe in Saint-Louis, Senegal. He worked as a nurse in a military hospital in Saint-Louis and obtained a scholarship to study veterinary medicine. He left Senegal to study at the University of Toulouse in France, where he received his degree as a veterinary surgeon. While studying in Paris, he met Leopold Senghor, the first president of Senegal and noted African poet, who later appointed Diop Sengalese Ambassador to Tunisia.

Speaking about Diop's *Tales of Amadou Koumba* as told by the griots (traditional West African storytellers), Senghor said Diop's work "restores the fables and ancient tales, in their spirit and in their style."

Diop won the French African Grand Prix in Literature in 1964. He died in Dakar in 1989 at the age of 83.

Bibliography

Jojo. Third Press, 1970.

Tales of Amadou Koumba. Translated by Dorothy S. Blair. Delacorte, 1981.

DUNBAR, PAUL LAURENCE (1872–1906)

Little brown baby wif' spa'klin' eyes,
Who's pappy's darlin' and' who is pappy's chile? . . .

Although he preferred writing in standard English, Paul Lawrence Dunbar was best known for his poetry in dialect. He was born in Dayton, Ohio, on June 27, 1872. His widowed mother, an ex-slave, married Joshua Dunbar, who died when Paul was twelve years old. His mother could read and write and encouraged young Paul with his writing. He attended Dayton public schools. At Central High School he had great success with his peers and teachers. He was a member of the school's literary society and wrote for the school paper, editing the paper in his senior year. Dunbar worked as an elevator operator and courthouse messenger, and while working at the Chicago World's Fair in 1893, he met Frederick Douglass, then commissioner of the Haitian exhibit, who hired him as a clerical assistant.

With the help of many white friends and the introduction written by the leading literary critic William Dean Howells to his third collection of poems *Lyrics of Lowly Life*, Dunbar achieved wide recognition. Tuskegee University's song was among his many works. In spite of his personal evaluation of his work, his dialect poetry is considered his best.

The poet married schoolteacher Alice Ruth Moore in 1898. From then until his death at the age of thirty-four he was active in social and educational circles.

Bibliography

Complete Poems of Paul Laurence Dunbar, with the Introduction to *Lyrics of Lowly Life* by W.D. Howells. Dodd, 1914.

Little Brown Baby. Edited by Bertha Rogers. Dodd, 1940.

EDWARDS, AUDREY (1947–)
Author

Born in Tacoma, Washington, Edwards earned her bachelor's degree at the University of Washington and her master's degree from Columbia University. She was a freelance writer, contributing articles to the *Daily News* and the *New York Times* and *Black Enterprise* and *Redbook* magazines. She was a senior editor of *Family Circle* magazine, a reporter for Fairchild Publications, and city editor of *Community News Service*, a black and Puerto Rican news service. She has also taught at New York University and the New School for Social Research.

Among her awards is the Coretta Scott King Fellowship from the American Association of University Women in 1969. She was the editor of *Essence* magazine from 1981 to 1986 and is currently the magazine's editor-at-large.

Edwards has been an associate editor of *Black Enterprise* magazine, 1978 to 1979, a regional director of the National Association of Black Journalists, 1981 to 1983, and program chair for the New York Association of Black Journalists since 1983. She was awarded the Unity Award from Lincoln University in 1985.

Bibliography

The Picture Life of Bobby Orr with Gary Wohl. Watts, 1976.

The Picture Life of Muhammad Ali with Gary Wohl. Watts, 1976.

Muhammad Ali, the People's Champ with Gary Wohl. Little, 1977.

Picture Life of Stevie Wonder with Gary Wohl. Watts, 1977.

EGYPT, OPHELIA SETTLE (1903–1984)
Author

Egypt was born in Clarksville, Texas. She worked as an educator, social service administrator, and writer. She will be remembered primarily for her work as director of a home for black unwed mothers and as founder in 1981 of one of Washington, D.C.'s first birth counseling clinics, the Parklands Egypt Clinic.

Educated at Howard University, the University of Pennsylvania, and Columbia University, Egypt was consultant to governmental and social service organizations and a member of many associations in the social service field. She was an instructor at Fisk University and assistant professor and field work supervisor at Howard University medical school.

Her *Unwritten History of Slavery* was a collection of interviews conducted with former slaves during her travels in Kentucky and Tennessee from 1929 to 1931. She received the Iota Phi Lambda Sorority's Woman of the Year Award in 1963, the International Women's Year Award, and the Club Twenty Award in 1975. At the time of her death in Washington, D.C., she was preparing a children's edition of her slave interviews.

Bibliography

James Weldon Johnson. Crowell, 1974.

ELLIS, VERONICA F. (1950–)
Author

> I always stress that teachers include multicultural children's books in the literature they present to students. American society is a mosaic of different cultures. Children must learn to understand the differences in people. The knowledge they gain from reading quality multicultural literature will ensure that understanding.

Ellis lives in Brockton, Massachusetts, with her husband and two children. A native of Liberia, West Africa, some of her ancestors were brought to the United States as slaves. In 1800 her maternal great-grandmother emigrated from Mississippi to Liberia. Her paternal grandfather, Varnie Marbu Fahnbulieh, was a chief of the Vai people of Liberia. Her maiden name, Freeman, is the English translation of the Vai word, *fahnbulleh*. She traces other ancestors to Ghana and the Ivory Coast.

Ellis received a bachelor of arts degree in English from Boston University in 1972 and a master's degree in education from Northeastern University in 1974. She has taught African culture and English from junior high school to the college level. For ten years she was a reading-textbook editor with the Houghton Mifflin Company in Boston.

She teaches writing at Boston University and children's literature at Wheelock College, also in Boston. She is a consultant/instructor for the Children's Literature In-Service Program, sponsored by the University of Massachusetts Davis Foundation and the Foundation for Children's Books in Massachusetts.

She is vice-president of the Liberian Organization for Voluntary Endeavors (L.O.V.E.). In 1990 she was recognized as a "distinguished role model" in Brockton, Massachusetts.

Bibliography

Afro-Bets First Book About Africa. Illustrated by George Ford. Just Us Books, 1990.

Emecheta, Buchi [Florence Onye] (1944–)
Author

The author was born in Lagos, Nigeria. Her father, a railroad porter, died when she was quite young. Emecheta displayed advanced intellectual ability at an early age and attended Methodist Girls' High School from age ten. After winning a scholarship to study in England, she followed her husband to London; they later separated and Emecheta was left to support their five children. She eventually earned an honor's degree in sociology from London University. Her persistence in writing and submitting manuscripts resulted in the publication of a number of her articles in the *New Statesman*. Since 1962 she has lived in London, where she works as a sociologist and writer of historical novels.

In 1978, the year she was recognized as the best black British writer, Emecheta won the Jock Campbell New Statesman Award for literature. Since 1979 she has been a member of the Home Secretary's Advisory Council, and in 1982–1983, she served in the Arts Council of Great Britain. In 1983 Emecheta was cited among the best British young writers.

Bibliography

Nowhere to Play. Illustrated by Peter Araber. Schocken, 1981.

The Moonlight Bride. Braziller, 1983.

The Wrestling Match. Braziller, 1983.

Evans, Mari (1926–)
Author

> Who I am is central to how I write and what I write; . . . I have
> written for as long as I have been aware of writing as a way
> of setting down feelings and the stuff of imaginings. My
> primary goal is to command the reader's attention. I un-
> derstand I have to make the most of the first few seconds his
> or her eye touches my material. . . .
>
> As a Black writer . . . approaching my Black family/
> nation from within a commonality of experience, I try for a
> poetic language that says, "This is who we are, where we
> have been, where we are. This is where we must go. And this
> is what we must do. (From *Black Women Writers, 1950–1980*.
> Edited by Mari Evans. Anchor/Doubleday, 1984.)

Evans was born in Toledo, Ohio, and attended the
University of Toledo. She later moved to Indianapolis,
Evans, well known for her talent as a musician, edu-
cator, and writer, was an associate professor in the
African Studies and Research Center at Cornell Uni-
versity, as well as writer-in-residence at many other
colleges and universities. At the same time, she was an
ethnic studies consultant for a publishing firm. She was
a television writer and directed "The Black Experience"
program. In addition to her political writings she has
written three volumes of poetry and four children's
books.

In 1985 she became visiting associate professor in
the Department of African Afro-American Studies, State
University of New York at Albany. Evans has taught
Afro-American literature at Indiana, Northwestern, and
Purdue universities and received the first annual Black
Academy of Arts and Letters Poetry Award. Evans was
awarded a Copeland Fellow from Amherst College in
1980 and the Black Arts Celebration Poetry Award in a
National Endowment for Arts Creative Writing Award
in 1981. In 1984 she was a Yaddo Writers Colony
Fellow.

Some of her poetry has been choreographed
(reinterpreted as a dance) and used in other media.

Bibliography

J.D. Doubleday, 1973.

I Look at Me. Third World, 1974.

Rap Stories. Third World, 1974.

Jim Flying High. Illustrated by Ashley Bryan. Doubleday, 1979.

FAUSET, JESSIE [REDMON] (1884?–1961)
Author

Fauset, the daughter of a minister, was born in Snow Hill, New Jersey. A writer of poetry, short stories, novels, and essays, she is best remembered as the first black female to graduate from Cornell University. She was a French teacher and the literary editor of *Crisis*.

She was instrumental in establishing the Harlem Renaissance literary foundation by encouraging and publishing works of the Harlem Renaissance literary greats, notably, Langston Hughes, Jean Toomer, and Countee Cullen, when she served as editor of *Crisis* and as editor and primary writer for the *Brownies Book*, a magazine for black children published by the NAACP. She died in Philadelphia on April 30, 1961.

Bibliography

The Brownies Book. Edited by Jessie Fauset. Dubois and Dill, 1920–1921.

FAX, ELTON C. (1909–)
Author/Illustrator

The artist was born in Baltimore and received his bachelor's degree from Syracuse University in 1931. Through the years he has given "Chalk Talks" lectures to groups in high schools and elsewhere. He has also worked as a United States Department of State Specialist in South America and the Caribbean, and in East Africa he represented the American Society of African Culture on tour in Nigeria in 1963. He has participated in international educational exchanges.

Fax has held memberships in the American Society of African Culture and the International Platform Association. He won the Coretta Scott King Award in 1972 for *Seventeen Black Artists*.

Bibliography

West African Vignettes. Dodd, 1963.

Contemporary Black Leaders. Dodd, 1970.

Seventeen Black Artists. Dodd, 1971.

Garvey: Story of a Pioneer Black Nationalist. Dodd, 1972.

Take a Walk in Their Shoes by Giennette Tilley Turner. Cobblehill/ Dutton, 1989.

FEELINGS, MURIEL [GRAY] (1938–)
Author

Feelings, born in Philadelphia, attended Philadelphia College of Art for one year on a partial scholarship. In 1963 she graduated from California State University at Los Angeles and worked as a teacher in New York. In New York she met several Africans, and in 1966 the Uganda Mission to the United Nations recruited her work as an art teacher in a Kampala high school. Her students' work was considered the basis for publishing literature by the Ministry of Education. However, because she believes factual information on Africa is needed, her first story was *Zamani Goes to Market.*

She married Tom Feelings, who had corresponded with her asking for Kampala folk literature. After returning to America she taught school in Brooklyn and introduced African crafts and Swahili; the experience culminated in *Moja Means One: Swahili Counting Book.* In 1971 the Feelingses went to work in Guyana. Muriel Feelings taught art in two high schools there; at one of the schools she assisted in editing booklets for school use. Upon her return to the United States she completed *Jambo Means Hello: Swahili Alphabet Book.* Both books, illustrated by her former husband, Thomas Feelings, have been widely honored, including winning the Caldecott Honor Book Award.

Muriel Feelings has lived in Philadelphia since, working for Afro-American concerns. She is currently working in a Philadelphia museum.

Bibliography

Zamani Goes to Market. Illustrated by Tom Feelings. Seabury, 1970.

Moja Means One: Swahili Counting Book. Illustrated by Tom Feelings. Dial, 1971.

Jambo Means Hello: Swahili Alphabet Book. Illustrated by Tom Feelings. Dial, 1974.

FEELINGS, THOMAS (1933–)
Illustrator

Tom Feelings, born and raised in Brooklyn, received a three-year scholarship to Cartoonists and Illustrators School after high school. After serving in the United States Air Force (1953–1959), he attended New York's School of Visual Arts. His comic strip, *Tommy Traveler in the World of Negro History*, was a feature of Harlem's newspaper *New York Age*.

In 1964 he worked in Ghana for the Ghana Government Publishing Company. He returned to the United States two years later and began working on children's books on African and Afro-American subjects. In his work for the Guyana government, 1971–1974, he served as a consultant for the Guyanese Children's Book Division and taught Guyanese illustrators.

He illustrated *Moja Means One* and *Jambo Means Hello*, Caldecott Honor Books written by his former wife, Muriel. The illustrations for *Something on My Mind* by Nicki Grimes, won the 1979 Coretta Scott King Award. *Daydreamers* by Eloise Greenfield was cited as an honorable mention in 1982. Feelings was awarded a National Endowment for the Arts Fellowship in 1982. In 1990 he started work at the University of South Carolina in Columbia as artist-in-residence.

Bibliography

To Be a Slave by Julius Lester. Dial, 1968

Moja Means One: Swahili Counting Book by Muriel Feelings. Dial, 1971.

Black Pilgrimage. Lothrop, 1972.

Jambo Means Hello: Swahili Alphabet Book by Muriel Feelings. Dial, 1974.

Something on My Mind by Nikki Grimes. Dial, 1978.

Daydreamers by Eloise Greenfield. Dial, 1981.

Tommy Traveler in the World of Black History. Black Butterfly, 1991.

FERGUSON, AMOS (1920–)
Illustrator

Amos Ferguson, who prefers to be called Mr. Amos Ferguson, was born in Exuma, the Bahamas. One of fourteen children, his preacher father, who was also a carpenter, inspired his Bible reading. Ferguson left home as a teenager and moved to Nassau, where he polished furniture and learned to paint houses until he decided to work as a house painter.

When he was a boy in school, he liked to sketch and eventually created what is called Jukanoo paintings. The subject matter of his paintings entirely reflect his Bahamian background and origin. His paintings are rich with the colors depicting the flora and fauna of the Bahamas; many display his deeply religious bent and interest in Bible readings.

Ferguson and his wife Bea, whom he claims is his inspiration and help in his choice of colors, live in an island home filled with the artist's paintings.

His exhibition at the Wadsworth Atheneum in Hartford, Connecticut, in 1985, traveled around the United States for two years. The Connecticut Public Television documentary on this island artist received an Emmy nomination.

Bibliography

Under the Sunday Tree. Poems by Eloise Greenfield. Harper, 1988.

FLOURNOY, VALERIE R. (1952–)
Author

Flournoy is the daughter of Payton I. Flournoy, Sr., retired Palmyra, New Jersey, chief of police. She is a twin and the third of five children. Her twin sister Vanessa is author of *All-American Girl*, a Silhouette First Love published in 1983 under the name Vanessa Payton. Her two brothers are both law enforcement officers.

Flournoy received her bachelor's degree and teacher's certification in social sciences (grades 7–12) from Hobart and William Smith College in Geneva, New York. Her writing interest grew from her publishing experience as a clerk-typist in the school and library services division of the Dell Publishing Company. She later became senior editor for Silhouette Romance Books/Pocket Books and editorial consultant for another romance line. Her *Patchwork Quilt* received a Christopher Award and the Ezra Jack Keats New Writer Award. The illustrations by Jerry Pinkney won the 1986 Coretta Scott King Award.

The author is a member of Black Women in Publishing and is associated with Vis a Vis Publishing in Palmyra, New Jersey, where she resides.

Bibliography

The Best Time of Day. Random House, 1978.

The Twins Strike Back. Dial, 1980.

The Patchwork Quilt. Illustrated by Jerry Pinkney. Dial, 1985.

FORD, BERNETTE G. [FORD, B.G.] (1950–)
Author

Bernette Ford recalls that she was a "dreamy child" who buried herself in books and was constantly reading. She grew up on Long Island, New York, the offspring of an interracial couple. Her mother, an African-American, and her father, a European American, instilled in her and her siblings a strong sense of identity. Both parents were deeply involved in the Civil Rights movement and often housed in their home children sent from Mississippi and Alabama.

Her mother was especially active as an actress, piano teacher, and director of a community theater. Ford's cousin, Douglas Turner Ward, was a founder of the Negro Ensemble Company, and she remembers how proud she was in junior high school when he elected to display her review of one of its earliest plays on the theater's bulletin board for months.

Ford's interest in books led to a career in publishing after college. She began work as an editorial assistant in the children's book division at Random House and was an editorial assistant from 1972 to 1977. In 1979 she was promoted to editor, and then moved to Golden Press, where she was a senior editor from 1979 to 1983. Later she became editorial director for Grosset and Dunlap, where she stayed for six years and was its vice-president and publisher when she left. She now works at Scholastic and has started her own imprint, Cartwheel Books, a selection of first books. With this imprint she is now the editorial director at Scholastic. Her interest in writing children's books has recently been whetted with the publication of her first book for Just Us Books.

Bibliography

Bright Eyes, Brown Skin with Cheryl Willis. Illustrated by George Ford, Jr. Just Us Books, 1990.

FORD, GEORGE, JR. (1936–)
Illustrator

> For an illustrator whose subject is the portrayal of black life and black children, it's important to use the book, or story, as a beginning, as means really, an opportunity to arouse in himself, and express to his readers, those broader human qualities that have helped us to survive this long—those qualities that are positive, full of energy and enthusiasm. All of these things I hope come out automatically, and inspire, and uplift, the people who read the books.
>
> The object of the drawing is not just to elicit admiration for one's technique, or admiration of any kind. Experimentation with techniques is valuable in the execution of a work and in tapping one's intuition, one's own creativity. But that is not the primary aim, which is that the content and the emotion in the work is far more important than stylistic innovation or anything of that sort, I strive to touch my reader at an emotional level, and thereby change his life.

The artist was born in Brooklyn and spent part of his childhood in Barbados. His early memories include those of a grandmother who constantly drew portraits on slate with chalk. He credits her with inspiring him to become an artist.

He studied in New York City the at Art Students League, Pratt Institute, Cooper Union, the School of Visual Arts, and City College. His art has appeared in *Harper's* magazine and the Brooklyn Museum, including the 1971 exhibition, "Black Artist in Graphic Communications." Ford was art director at Eden Advertising in New York and design director of *Black Theater* magazine. He illustrated the 1974 winner of the Coretta Scott King Award—*Ray Charles* by Sharon Bell Mathis.

Ford is married to author Bernette G. Ford. The couple have one daughter and live in Brooklyn.

Bibliography

The Singing Turtle and Other Tales from Haiti by Phillipe Thoby-Marcelin. Farrar, 1971.

Walk On by Mel Williamson and George Ford, Jr. Third Press, 1972.

Ray Charles by Sharon Bell Mathis. Crowell, 1973.

Ego Tripping and Other Poems for Young People by Nikki Giovanni. Lawrence Hill, 1974.

Paul Robeson by Eloise Greenfield. Crowell, 1975.

Far Eastern Beginnings by Olivia Vlahos. Viking, 1976.

Afro-Bets First Book About Africa by Veronica F. Ellis. Just Us Books, 1989.

Bright Eyes, Brown Skin by Cheryl Willis Hudson and Bernette G. Ford. Just Us Books, 1990.

Fufuka, Karama [Sharon Antonia Morgan] (1951–)
Author

Born in Chicago, Fufuka attended Loop City College, one of the Chicago city colleges. She has a variety of interests and work experiences as secretary, receptionist, and associate director of the Provident Community Development Corporation. She has contributed articles to *Ebony Jr.*, *Essence*, and *Lifestyles* and has been an editor of the *Woodburn Community Observer* since 1975.

Bibliography

My Daddy Is a Cool Dude and Other Poems. Illustrated by Mahiri Fufuka. Dial, 1975.

GAYLE, ADDISON (1932–1991)
Author

The author, born in Newport News, Virginia, received his bachelor's degree from the City College of New York and his master's degree from the University of California in Los Angeles.

A teacher of writing and literature, Gayle was a professor of American and Afro-American literature at the University of Washington and has lectured at City College, serving on the chancellor's committee on prisons and the graduate center's committee on English programs. He was a consultant to minority writers at Doubleday and Random House publishers and has been on the editorial staffs of *Amistad* magazine, *Third World Press*, and *Black World* magazine, he also sponsored the Richard Wright Award for the minority scholarship program, SEEK, given each semester to the student with the highest scholastic average. Gayle was a member of P.E.N. International and the Authors Guild, and a Distinguished Professor of English at Bernard Baruch College in New York.

Bibliography

Oak and Ivy: A Biography of Paul Laurence Dunbar. Doubleday, 1981.

GILCHRIST, JAN (JANICE) SPIVEY (1949–)
Illustrator

> As in over twenty years of fine art works having the same philosophy, I wish to always portray a positive and sensitive image for all children, especially the African-American Children.

Gilchrist obtained her bachelor of science degree in art education at Eastern Illinois University in 1973 and her master of arts degree in painting from the University of Northern Iowa in 1979. She received the 1990 Coretta Scott King Award for her illustrations in *Nathaniel Talking* by Eloise Greenfield. For five years she was awarded Purchase awards at the Dusable Museum in Chicago and was given the first award in 1985 from the National Academic Artists Association. Her art has been featured in exhibitions throughout the United States and Canada. An honorary member of Alpha Kappa Alpha Sorority and a member of Phi Delta Kappa, Gilchrist has memberships at the Southside Community Art Center, Chicago, and the Illinois Artisan Shop.

Gilchrist and her husband Kelvin Keith Gilchrist live in suburban Chicago. They have two children.

Bibliography

Children of Long Ago by Lessie Jones Little. Philomel, 1988.

Nathaniel Talking by Eloise Greenfield. Black Butterfly, 1989.

Night on Neighborhood Street by Eloise Greenfield. Dial, 1991.

GIOVANNI, NIKKI [YOLANDA C.] (1943–)
Author

> It's always a bit intimidating to try to tell how I write since I, like most writers, I think, am not all sure that I do what I do in the way that I think I do it. . . .
> . . . I resist questions about my own work. I like to think that if truth has any bearing on art, my poetry and prose is art because it's truthful.
> . . . We who are writers live always in three time zones: past, present, and future. We pay respect to them all as we share an idea. . . . I have always been a lover of books and the ideas they contain. Sometimes I think it is easy for us who write to forget that it is only half the process; someone must read. . . . There is always someone to remind us that there must be more to living than what we currently see. And that unusual person is what we seek.
> . . . We write, because we believe that the human spirit cannot be tamed and should not be trained. (From *Black Women Writers, 1950–1980.* Edited by Mari Evans. Anchor/Doubleday, 1984.)

Giovanni earned her bachelor's degree at Fisk University and later attended the University of Pennsylvania School of Social Work and Columbia University. Among her awards are a Ford Foundation grant in 1968 and a National Endowment for the Arts grant in 1969. Honorary doctorates from Wilberforce University, Smith College, and the University of Maryland, and a citation from *Ebony* in 1969 as one of the ten most admired black women have made her much in demand on the lecture circuit.

Giovanni was assistant professor of black studies at Queens College of the City University of New York, Associate Professor of English at Livingston College, Rutgers University, and an editorial consultant for *Encore* magazine. Giovanni is currently a professor of English at Virginia Polytechnic Institute and State University in Blacksburg.

Bibliography

Spin a Soft Black Song: Poems for Children. Illustrated by Charles Bible. Hill and Wang, 1971.

Ego Tripping and Other Poems for Young Readers. Illustrated by George Ford, Jr. Lawrence Hill, 1973.

Vacation Time Poems for Children. Morrow, 1981.

GRAHAM, LORENZ [BELL]
(1902–1989)
Author

Graham was born in New Orleans and educated at the University of California in Los Angeles. He also attended Virginia Union, New York School of Social Work, and New York University. He taught at Monrovia College, Liberia, from 1925 to 1929. He was a probation officer, social worker, and camp adviser for the Civilian Conservation Corps, Virginia, from 1934 to 1945 as well as a writer.

His memberships include Kappa Alpha Psi, Southern California Writers' Guild, Authors' League of America, and P.E.N. International. Among his awards are the Thomas Alva Edison Foundation Citation, 1956; the Charles W. Follett Award, 1958; the Southern California Council of Literature for Children and Young People Award, 1968; and first prize from Book World, 1969.

The religious influence of his minister father is reflected in Graham's early work. His own trip to Liberia to teach in a missionary school heightened his awareness of the African people and inspired him to try to dispel some of the stereotypes he had read in books. His first book, *How God Fix Jonah* (1946), was followed by other Bible stories for young readers using the African speech patterns he had heard. It was his sister, Shirley Graham, the widow of W.E.B. Du Bois, who alerted publishers to her brother's stories.

Later Graham dealt more directly with race relations in the United States with *South Town* (1958), *North Town* (1963) and *Whose Town?* (1969). These three books, a trilogy, was a continuing saga of a family in a small southern town and later in an urban setting in the North, where racial tensions were even greater after World War II and the Korean War and the disparities between the races was quite pronounced.

He was married to Ruth Morris, and they had four children.

Bibliography

How God Fix Jonah. Crowell, 1946.

South Town. Follett, 1958.

North Town. Crowell, 1963.

Whose Town? Crowell, 1969.

Every Man Heart Lay Down. Illustrated by Colleen Browning. Crown, 1970.

God Wash the World and Start Again. Crowell, 1971.

Song of the Boat. Crowell, 1975.

Return to South Town. Crowell, 1976.

John Brown: A Cry for Freedom. Crowell, 1980.

Graham, Shirley Lola
[Mrs. W.E.B. Du Bois]
(1906–1977)
Author

Graham was born in Indianapolis. She studied music in Paris, obtained a French certificate from the Sorbonne, and earned her bachelor's and master's degrees from Oberlin College. She also studied at Yale University Drama School and received an honorary doctor of letters from the University of Massachusetts in 1973.

Her work experience included her position as head of the fine arts department of Tennessee State College, director of the Chicago Federal Theater, YWCA director, field secretary for the NAACP, director of Ghana Television, founding editor of *Freedomways* magazine, and English editor in 1968 of the Afro-Asian Writers Bureau in Peking (Beijing).

She received many awards including a Rosenwald and Guggenheim fellowship from Yale University Drama School for historical research and in 1950 the Julian Messner Award for *There Was Once a Slave*.

She married twice and had one son from her first marriage. Noted black educator and author W.E.B. Du Bois was her second husband. She died in Peking (Beijing) on March 27, 1977, at age 69.

Bibliography

Booker T. Washington: Educator of Hand, Head and Heart. Messner, 1955.

Paul Robeson: Citizen of the World. Messner, 1971.

Julius K. Nyerere: Teacher of Africa. Messner, 1975.

GREENFIELD, ELOISE [GLYNN LITTLE] (1929–)
Author

> I attempt to depict African American people and their lives with accuracy, depth and balance, always keeping in mind the need to counteract the stereotypes that are so prevalent in the general body of literature and other media. I write with the hope that my work will inspire in readers a love for language, a love for themselves and a commitment to humane values.
>
> I hope that I can contribute a little in moving children toward their best selves.

Greenfield was born in Parmele, North Carolina, to Weston Wilbur Little, Sr., and Lessie Blanche [Jones] Little, who collaborated in later years with her daughter Eloise in writing two children's books.

Greenfield has had a number of secretarial positions and has worked as an administrative assistant in the Department of Occupations and Professions. Her memberships include the adult fiction and children's literature divisions of the D.C. African American Writers Guild. She served as writer-in-residence at the D.C. Commission on the Arts and Humanities in 1973 and again from 1975 to 1987. She has been a lecturer and workshop leader in children's literature and has received several awards and citations for her books.

In 1974 *Rosa Parks* was cited by the National Council for Social Studies and *She Come Bringing Me That Little Baby Girl* won the Irma Simonton Black Award as well as being an American Library Association Notable Book. In 1976 *Paul Robeson* won the Jane Addams Award and *Africa Dream* won the 1978 Coretta Scott King Award. In 1983 Greenfield received the Mayor's Art Award in Literature in Washington, D.C. Her grants have come from the D.C. Commission on the Arts and Humanities.

On March 8, 1991, a school library was opened and dedicated at P.S. 268 in Brooklyn. At the suggestion of a child, it was named the Eloise Greenfield library. It is one of 100 school libraries in a project supported by the DeWitt Wallace-Readers Digest Fund.

Greenfield, who was formerly married to Robert J. Greenfield, has a son Steven R. and a daughter Joyce.

Bibliography

Rosa Parks. Crowell, 1973.

She Come Bringing Me That Little Baby Girl. Illustrated by John Steptoe. Lippincott, 1974.

Paul Robeson. Illustrated by George Ford, Jr. Crowell, 1975.

Africa Dream. Illustrated by Carole Bayard. Day, 1977.

Mary McCleod Bethune. Illustrated by Jerry Pinkney. Crowell, 1977.

Honey, I Love. Crowell, 1978.

Childtimes: A Three-Generation Memoir with Lessie Jones Little. Illustrated by Jerry Pinkney. Crowell, 1979.

Grandmama's Joy. Illustrated by Carole Bayard. Philomel, 1980.

Alesia with Alesia Revis. Philomel, 1981.

Daydreamers. Illustrated by Thomas Feelings. Dial, 1981.

Grandpa's Face. Illustrated by Floyd Cooper. Philomel, 1988.

Under the Sunday Tree. Paintings by Mr. Amos Ferguson. Harper, 1988.

Nathaniel Talking. Illustrated by Jan Spivey Gilchrist. Black Butterfly, 1989.

Night on Neighborhood Street. Illustrated by Jan Spivey Gilchrist. Dial, 1991.

GRIFFIN, JUDITH BERRY
Author

After leaving a teaching career in New York City, Griffin became director of A Better Chance, an organization that searches out and identifies achieving minority youth who may be qualified to enter private or preparatory schools in the United States. The board of A Better Chance is composed of corporation heads and individuals who help in the funding and provision of the scholarships for these students, many of whom are African American.

It is possible that Griffin's own attendance at the Lab School at the University of Chicago helped prepare her for this job. She resides in Washington, D.C., and Boston, Massachusetts.

Bibliography

Nat Turner. Coward, 1970.

The Magic Mirrors. Coward, 1971.

Phoebe and the General. Illustrated by Margot Tomes. Coward, 1971.

Phoebe the Spy. Scholastic, 1989.

GRIMES, NIKKI (1950–)
Author

Grimes majored in English and studied African languages at Livingston College, Rutgers University. She received a Ford Foundation grant in 1974 that enabled her to spend a year in Tanzania collecting folktales and poetry. Journalism, photography, and poetry writing have kept her busy since 1975. Her poetry often appears in anthologies of modern American poetry. She lives in New York City.

Bibliography.

Growin'. Illustrated by Charles Lilly. Dial, 1977.

Something on My Mind. Illustrated by Tom Feelings. Dial, 1978.

GUIRMA, FREDERIC
Author/Illustrator

Guirma was born in Ouagadougou, Upper Volta. He claims Naba Koumdoum 'ue,' the eighth emperor of the Mois people in the fourteenth century, to be one of his ancestors. Guirma attended an elementary school taught by the Sisters of Our Lady of Africa and later the Seminary of Padre. He received his bachelor's degree in France and a master's degree from Loyola University in Los Angeles.

He has been secretary of the French Embassy in Ghana and served as vice-counsul in Kumesi, Ghana. When Upper Volta became an independent nation in 1960, he was its first ambassador to the United Nations and Washington, D.C. He has also been senior political affairs officer at United Nations headquarters in New York.

In his spare time Guirma writes and paints. His book *Princess of the Full Moon*, which he wrote and illustrated, is based on folklore of Upper Volta.

Bibliography

Princess of the Full Moon. Macmillan, 1970.

Tales of Mogho: African Stories from Upper Volta. Macmillan, 1971.

GUY, ROSA [CUTHBERT] (1928–)
Author

Rosa Guy was born in Trinidad, the daughter of Henry and Audrey (Gonzales) Cuthbert. She was brought to the United States in 1932, grew up in Harlem, and later attended New York University.

Guy is a founder and former president of the Harlem Writers Guild. She has traveled to Senegal, Mali, Gambia, Algeria, Nigeria, Haiti, and to her birthplace. She speaks French and Creole and re-searches African articles.

Her magazine articles have appeared in *Cosmopolitan* and *Freedomways*. *The Friends*, first of a trilogy of novels for young people, was cited as among the "Best Books for Young Adults" by the American Library Association and selected as the *New York Times* Outstanding Book of the Year in 1976. Other books in the trilogy are *Ruby* and *Edith Jackson*. Guy's book for younger children, *Mother Crocodile*, illustrated by John Steptoe, was an American Library Association Notable Book and won the 1982 Coretta Scott King Award. Guy is the widow of Warner Guy. She has one son, Warner.

Guy writes adult books and short stories as well as books for young readers and young adults. The musical play *Once on This Island* performed during the 1991 season on Broadway, is based on the author's novella, "My Love, My Love or the Peasant Girl, A Fable."

Bibliography

The Friends. Holt, 1973.

Ruby. Viking, 1976.

Edith Jackson. Viking, 1978.

Mother Crocodile = Maiman-Caiman. Retold and translated. Illustrated by John Steptoe. Delacorte, 1981.

New Guys Around the Block. Viking, 1983.

Paris, Pee Wee and Big Dog. Illustrated by Caroline Binch. Delacorte, 1984.

And I Heard a Bird Sing. Delacorte, 1987.

The Ups and Downs of Carl Davis III. Delacorte, 1989.

HAMILTON, VIRGINIA ESTHER (1933–)
Author

Hamilton was born in southern Ohio, where her maternal ancestors settled after the Civil War. John Rowe Townsend, in *Written for Children*, describes Virginia Hamilton as "the most subtle and interesting of today's black writers for children." Hamilton's books have always centered around black heritage and more personally around her own family history. Her themes go beyond family experiences, weaving mysticism, fantasy, and realism.

Hamilton has received many major literary awards and much recognition for her children's books. *M.C. Higgins, the Great* won the 1975 Newbery Medal, the National Book Award, and the Boston Globe–Horn Book Award. *The Planet of Junior Brown* and *Sweet Whispers, Brother Rush* were Newbery Honor Books. She was also awarded two certificates of honor by the International Board of Books for the Young People (IBBY) for these books. The awards cited the books as outstanding examples of literature with international importance. Hamilton won the Coretta Scott King Award in 1983 and 1986. "The Virginia Hamilton Lectureship on Minority Experiences in Children's Literature" at Kent State University was established in her honor. Her novel, *The House of Dies Drear,* was produced for television by the Public Broadcasting System (PBS).

Hamilton credits her parents Kenneth and Etta Belle Perry Hamilton for her storytelling ability. She now resides in Yellow Springs, Ohio, with her husband, poet Arnold Adoff, and their two children. Hamilton and Adoff were writers-in-residence at Queens College of the City University of New York for 1987 and 1988.

Bibliography

Zeely. Macmillan, 1967.

The House of Dies Drear. Collier, 1968.

The Time-Ago Tales of Jadhu. Macmillan, 1968.

The Planet of Junior Brown. Macmillan, 1971.

M.C. Higgins, the Great. Macmillan, 1974.

Paul Robeson: The Life and Times of a Free Black Man. Harper, 1974.

The Writings of W.E.B. Du Bois. Edited by Virginia Hamilton. Crowell, 1975.

Sweet Whispers, Brother Rush. Philomel, 1982.

The Magical Adventures of Pretty Pearl. Harper, 1983.

A Little Love. Philomel, 1984.

The People Could Fly. Illustrated by Leo and Diane Dillon. Knopf, 1985.

Junius Over Far. Harper, 1985.

The Mystery of Drear House. Greenwillow, 1987.

Anthony Burns: The Defeat and Triumph of a Fugitive Slave. Knopf, 1988.

In the Beginning: Creation Stories Around the World. Retold by Virginia Hamilton. Illustrated by Barry Moser. HBJ, 1988.

The Bells of Christmas. Illustrated by Lambert Davis. HBJ, 1989.

Cousins. Philomel, 1990.

The Dark Way: Stories from the Spirit World. Illustrated by Lambert Davis. HBJ, 1990.

The All Jadhu Storybook. Illustrated by Barry Moser. Dial, 1991.

HANNA, CHERYL IRENE (1951–)
Illustrator

> Illustrations should be visual joys uplifting children who don't always have other sources of formal beauty around them. The African image is often not seriously introduced in positive ways for all children. For the African American child, the illustrations should be as love letters.

Cheryl Hanna remembers drawing seriously from about age five, encouraged to continue by her grandmother and younger brother. She was born in Ann Arbor, Michigan, and was the daughter of a local dentist, Leonard Morton Hanna. After attending Cass Tech High School, in Michigan, from which she graduated in 1969, the artist attended Pratt Institute in New York from 1969 to 1973.

An Enchanted Hair Tale by Alexis Deveaux, for which Hanna did the illustrations, was cited as an ALA Notable Book in 1987 and awarded a social studies citation.

Hanna's art has been exhibited in fine arts solo exhibitions at the Cinque Gallery, the Brooklyn Museum of Art, the Sherry Washington Fine Arts Museum in Detroit, and the June Kelly Gallery in New York City. She is a member of the Schomburg Center for Black Culture in Harlem and the Children's Book Interest Group of Illustrators.

Bibliography

An Enchanted Hair Tale by Alexis Deveaux. Harper, 1987.

Hard to Be Six by Arnold Adoff. Lothrop, 1990.

Next Stop Freedom by Dorothy and Thomas Hoobler. Silver Burdett, 1991.

HANSEN, JOYCE VIOLA (1942–)
Author

> Some writers have recurring or favorite themes—mine are
> the importance of family, belief in self, maintaining a sense
> of hope and a determination to overcome obstacles, and
> being responsible for oneself and other living things.
> I try to flesh out those things that are intrinsic to the
> Afro-American experience—those positive aspects of our
> lives that should not be discarded—our extended families,
> our concern and respect for the elderly, and our sense of
> community.

Hansen was born in New York, attended Pace University, and received her master's degree from New York University in 1978. She has worked as an administrative assistant at Pace University and since 1973 as a teacher of remedial reading and English for the New York City Board of Education. Her novel *The Gift Giver* received the Spirit of Detroit Award and was also designated Notable Children's Trade Book in the field of social studies in 1980. Hansen claims that her stories come from youngsters: "My own stories come as chunks of reality—ideas that are generated by the young people I know and work with."

In 1986 Hansen won the Parents Choice Award, and in 1987 the Coretta Scott King Award Honor Citation for *Which Way Freedom?* Her memberships include the Society of Children's Book Writers and the Harlem Writers Guild.

She is married to photographer Austin Hansen and lives in New York City.

Bibliography

The Gift Giver. Houghton, 1980.

Home Boy. Clarion, 1982.

Yellow Bird and Me. Clarion, 1986.

Which Way Freedom? Walker, 1986.

Out From This Place. Walker, 1988.

Haskins, James S. (1941–)
Author

The author, a prolific writer, was born in Demopolis, Alabama, where he remembers a childhood "in a household with lots of children." He attended high school in Boston and college "in a variety of places. . . . I write books for adults, but most of the books I write are for young people. It is my feeling that adults either read or do not read depending on how they felt about books when they were young . . . my own experiences, from childhood on, is that reading books is a nice way to carve out your own private world and learn about the big world at the same time. But you must find out about the wonder of reading when you are young. If you find in out then, it doesn't matter whether you are allowed into the library or not; you will find a way to get books."

Haskins has a bachelor's degree in psychology from Georgetown University and one in history from Alabama State University; he received his master's degree from the University of New Mexico in 1963. He also attended the New York Institute of Finance, earning a certificate of work of the Stock Exchange. He has attended the New School for Social Research and Queens College of the City University of New York's graduate program in psychology. He has taught in high school and college; he is currently a professor in the English department at the University of Florida in Gainesville.

His memberships include Phi Beta Kappa; the National Advisory Committee, Statue of Liberty—Ellis Island Commission, National Book Critics Circle; 100 Black Men; and the Authors Guild. Many of his books have been selected as notable children's books by *Social Studies* magazine. *Barbara Jordan* was selected by the Child Study Association in 1979, and the *Story of Stevie Wonder* won the Coretta Scott King Award in 1977.

Bibliography

The Picture Life of Malcolm X. Watts, 1975.

The Creoles of Color. Illustrated by Don Miller. Crowell, 1975.

The Story of Stevie Wonder. Lothrop, 1976.

Barbara Jordan. Dial, 1977.

Andrew Young: Man with a Mission. Lothrop, 1979.

James Van Der Zee: The Picture Takin' Man. Dodd, 1979.

The New Americans: Vietnamese Boat People. Enslow, 1980.

Black Theatre in America. Crowell, 1982.

Lena Horne. Coward, 1983.

Space Challenger: The Story of Guion Bluford with Kathleen Benson. Carolrhoda, 1984.

Black Music in America: A History Through Its People. Crowell, 1987.

Count Your Way Through China. Illustrated by Dennis Hockerman. Carolrhoda, 1987.

Count Your Way Through Japan. Illustrated by Martin Skoro. Carolrhoda, 1987.

Count Your Way Through Russia. Illustrated by Vera Mednikov. Carolrhoda, 1987.

Count Your Way Through the Arab World. Illustrated by Dana Gustafson. Carolrhoda, 1987.

Bill Cosby: America's Most Famous Father. Walker, 1988.

Winnie Mandela: Life of Struggle. Putnam, 1988.

Count Your Way Through Africa. Illustrated by Barbara Knutson. Carolrhoda, 1989.

Count Your Way Through Canada. Illustrated by Steve Michaels. Carolrhoda, 1989.

Count Your Way Through Korea. Illustrated by Dennis Hockerman. Carolrhoda, 1989.

Count Your Way Through Mexico. Illustrated by Helen Beyers. Carolrhoda, 1989.

Count Your Way Through Germany. Illustrated by Helen Beyers. Carolrhoda, 1990.

Count Your Way Through Italy. Illustrated by Beth Wright. Carolrhoda, 1990.

Count Your Way Through Israel. Illustrated by Rick Hanson. Carolrhoda, 1990.

Black Dance in America: A History Through Its People. Harper, 1990.

Outward Dreams: Black Inventors and Their Inventions. Walker, 1991.

Against All Odds: Black Explorers in America. Walker, 1991.

Rosa Parks: Mother to a Movement by Rosa Parks with James Haskins. Dial, 1992.

Howard, Elizabeth Fitzgerald (1927–)
Author

> There are so many many wonderful inspiring funny sad heartwarming heart-tickling meaningful stories about black families, waiting to be written down. Some of them are in my own family's treasury, and there is still a shortage—a dearth—of children's books about everyday black families living ordinary lives during the early part of this century—books that emphasize not the difficulties and the unfairness and the prejudice and other adversity which were a part of the lives of all blacks . . . and everyone had to cope. . . . But I would like present-day children, black and white, to know that blacks have been a part of all of this country's growth since the beginning. And that there were black grocers and doctors and postmen and teachers and porters and lawyers who celebrated holidays and sat in the balcony at the opera and went to church and sent their children to college—and hoped that the American dream included them. And lived as though it did, in spite of everything that might or might not have gone wrong. Of course, Virginia Hamilton and Patricia McKissack and others are telling this story with depth and flair. I hope that I am able in some small measure to contribute to this.

Thus has Elizabeth Howard, an associate professor of library science at West Virginia University, stated her underlying philosophy in her works.

Howard earned her bachelor of arts degree at Radcliffe College in 1948 and her master's degree in library science and her doctorate at the University of Pittsburgh in 1971 and 1988, respectively. In her senior year, she was president of her class at Radcliffe.

Her memberships include the American Library Association (ALA), Children's Literature Association and the Society of Children's Book Writers. She has served on the Caldecott Committee, the Hans Christian Andersen Committee, and Teachers of Children's Literature Discussion Group in ALA. Presently, she is a

member of the Board of Magee Women's Hospital, as chair of the Ethics Committee, the QED communications and Beginning with Books. She has also been on the board of trustees of Ellis School, the Pittsburgh Board of Management, Radcliffe Alumnae Association, Deputy to the Episcopal Diocesan Convention, and the Parish Council of the Calvary Episcopal Church, and Member Links, Inc.

She is married to Lawrence C. Howard, and they have three daughters.

Bibliography

The Train to Lulu's. Illustrated by Robert Casilla. Bradbury, 1988.

Chita's Christmas Tree. Illustrated by Floyd Cooper. Bradbury, 1989.

Aunt Flossie's Hats (and Crab Cakes Later). Illustrated by James Ransome. Clarion, 1991.

HOWARD, MOSES LEON [MUSA NAGENDA] (1928–)
Author

The author, born in Copiah County, Mississippi, received his bachelor's degree at Alcorn A.&M. College and his master's degree from Case Western Reserve University. He did further graduate study at the University of Alaska, New York University, and Columbia University.

Howard has worked as a steelworker, biology and chemistry instructor, and science department head at National Teachers' College in Uganda and served at the African Ministry of Education in Kampala, Uganda. He taught public school in Seattle. Howard was named Outstanding Educator of the Year in Washington state in 1981.

Bibliography

Dogs of Fear. Holt, 1972. (Published under the name Musa Nagenda).

The Human Mandolin. Holt, 1974.

The Ostrich Chase. Holt, 1974.

HUDSON, CHERYL WILLIS (1948–)
Author

> African American children have a right to see themselves portrayed positively and accurately in the literature of this society. Just Us Books specializes in books and learning material for children that focus on the African American experience.

Cheryl Hudson feels that she and her husband, Wade Hudson, have achieved this goal in the books that they publish in the publishing company that they founded, Just Us Books, Inc. The author was born in Portsmouth, Virginia, and for over 20 years worked in publishing as a graphic designer and art director. She has worked with the publishers Macmillan Company of New York City and Arete Publishing Company of Princeton, New Jersey as an assistant art director and with Houghton Mifflin of Boston as an art director. As a freelance design consultant, she designed and directed art projects for Waldenbooks, Longmeadow Press, and Angel Entertainments' series of graphic novels, *Pink Flamingos*, which was published by Simon & Schuster.

A graduate of Oberlin College, where she received a bachelor of arts degree, she also took publishing courses at Radcliffe College and a post-baccalaureate in 1972 at Northeastern University with study in graphic arts management. From 1973 to 1975 she pursued further studies at the Parsons School of Design in New York City.

Some of Hudson's poetry for children and her illustrations have appeared in *Ebony Jr.* and *Wee Wisdom* magazines. She is a member of the Multicultural Publishers Exchange.

She and her husband, Wade, live in East Orange, New Jersey, with their son and daughter.

Bibliography

Afro-Bets A B C Book. Illustrated by George Ford. Just Us Books, 1987.

Afro-Bets 1 2 3 Book. Just Us Books, 1988.

Bright Eyes, Brown Skin with Bernette G. Ford. Just Us Books, 1990.

HUDSON, WADE (1945–)
Author

> One can never take any image for granted. Images, whether in print, film, television, or on the stage, are constantly shaping the way we feel and what we think and believe. This is particularly crucial to the African American community that has been deliberately given negative images of its history and culture. I find it rewarding to help reshape and change those negative images to reflect truth. I think the struggle to present the correct images, the truth, is the most crucial one facing us all.

Wade Hudson, president and CEO of Just Us Books, the publishing company he and his wife founded, was born in Mansfield, Louisiana, and attended the Southern University in Baton Rouge. He was active as a "field worker" during the civil rights movement of the 1960s and has pursued a career in public relations working as a PR specialist at Essex County College and Kean College in New Jersey. He has also been a sports writer, a sports editor, and a playwright. He and his wife Cheryl and son and daughter live in East Orange, New Jersey.

Bibliography

Beebe's Lonely Saturday. New Dimension Publishing Company, 1967.

Freedom Star. Macmillan, 1968.

Afro-Bets Book of Black Heroes from A to Z with Valerie Wilson Wesley. Just Us Books, 1988.

Hughes, Langston [James] (1902–1967)
Author

Dubbed the "Negro Poet Laureate," Langston Hughes, a product of the Harlem Renaissance, was a tremendously prolific writer. He was born in Joplin, Missouri, in 1902, son of James Nathaniel Hughes and Carrie Langston Hughes. He lived with his grandmother in Kansas after his parents' separation. When his mother remarried, young Hughes lived with her and his stepfather in Cleveland.

He started to write poetry in the eighth grade and was elected class poet. After high school graduation Hughes visited his father in Mexico, and to please him attended Columbia University, though he only stayed one year. Then began his travels to Europe and Africa, an opportunity to experience life, observe people, and work at various jobs before returning to the United States.

In 1929 he graduated from Lincoln University. In 1935 he won a Guggenheim Fellowship and in 1941 a Rosenwald Fellowship, the first of a host of honors he was able to received for his writing. Hughes wrote poetry, short stories, plays, newspaper articles and columns, a novel, essays, lyrics for a successful musical, and children's books. His poetry is a mix of blank verse, dialect, and lyric verse, reflecting his interest in language, rhythm, and the music he loved—jazz and the blues. His prize works demonstrate his political and social activism and his disapproval of civil injustices against his people. His work is distinguished by its brilliant humor and witty satire.

In 1946 he was elected member of the National Institute of Arts and Letters; he was a visiting professor of creative writing at Atlanta University, 1947–1948; and poet-in-residence at the Laboratory School, Uni-

versity of Chicago in 1949–1950. His honorary doctor-ates were awarded by Lincoln University and Case Western Reserve University. His living depended solely on his earnings from writing and lecturing. He made his home in his beloved Harlem.

Bibliography

The Dream Keeper and Other Poems. Illustrated by Helen Sewell. Introduction by Augusta Baker. Knopf, 1937, 1986.

Famous American Negroes. Dodd, 1954.

Famous Negro Music Makers. Dodd, 1954.

The First Book of Africa. Watts, 1964.

Black Misery. Erikson, 1969.

Don't You Turn Back. Selected by Lee Bennett Hopkins. Knopf, 1969.

Jazz (original title, *The First Book of Jazz*). Updated Edition. Watts, 1982.

A Pictorial History of Black Americans with Milton Meltzer and C. Eric Lincoln. Fifth Revised Edition. Crown, 1984.

HUMPHREY, MARGO (1942–)
Author/Illustrator

> Although my work covers a broad spectrum of subjects, many subjects are used as icons, as testament to the triumph of existence.
>
> My artwork and stories deal with empowerment and the nobility of culture.

Born in Oakland, California, Humphrey is primarily an artist. She attended the California College of Arts and Crafts in that city where she earned her Bachelor of Fine Arts in painting and printmaking in 1973. In 1974, she received her Master of Fine Arts in printmaking from Stanford University in Palo Alto, California.

The artist recalls writing poetry as a small child and always occupying her time by drawing. She attributes her artistic leanings to her creative parents—her mother designed on fabrics and was also a milliner, and her father stressed academic discipline and strong interest in music.

Humphrey has worked as an art specialist for the State Department, United States Information Service; the Yaba Technical Institute in Ekoi Island, Nigeria; the University of Benin in Benin City, Nigeria, in 1987; and the Margaret Trowell School of Fine Art in Uganda, in 1988. Since then she has worked at the National Gallery of Art in Harare in Zimbabwe.

Active as a lecturer and exhibitor, Humphrey has also been the recipient of numerous awards. She was honored by the NAACP's Women's Caucus for Art and the Black Filmmaker's Hall of Fame. In 1989 she was the first American artist to open the American section and exhibit in the National Gallery of Nigeria's Permanent Collection, and in the same year, she was proclaimed "Artist of the Muses" for teaching and community contributions in San Antonio, Texas.

In 1980–1981 she was awarded a Ford Foundation grant for printmaking and in 1983 the James D. Phelan

Award from the World Print Council in San Francisco. She received a Mid-Atlantic Arts grant for Creative and Performing Arts in the summer of 1990 and in 1991 the Oakland Chamber of Commerce award as Individual Artist.

The divorced mother of twins, Humphrey is currently an assistant professor in the Department of Art at the University of Maryland, College Park, Maryland. She resides in Oakland, California.

Bibliography

The River That Gave Gifts: An Afro-American Story. Children's Book Press, 1987.

HUNTER, KRISTIN (1931–)
Author

Hunter was born in Philadelphia and attended school there, receiving her bachelor's degree in 1951 in education from the University of Pennsylvania. She has been a teacher, copywriter for Lavenson Bureau of Advertising in Philadelphia, research assistant at the University of Pennsylvania's School of Social Work, and the City of Philadelphia's Information Officer.

Her awards and honors include a Fund for the Republic Prize for a television documentary, the Book World Festival Award, the Council for Interracial Books for Children Award in 1968, the Christopher Award in 1974, a Whitney Fellowship, a Sigma Delta Chi Award for reporting, and a Brotherhood Award from the National Conference of Christians and Jews. She currently lectures in creative writing at the University of Pennsylvania.

Bibliography

The Soul Brothers and Sister Lou. Scribner, 1968.

Boss Cat. Scribner, 1971.

Guests in the Promised Land. Scribner, 1973.

Lou in the Limelight. Scribner, 1981.

JACKSON, JESSE (1908–1983)
Author

The author was born in Columbus, Ohio, and attended Ohio State University, where he was active in boxing and track. He entered the Olympic trials and planned to become a professional boxer, but he later changed his mind. His summers were spent at various jobs: boxing in a carnival, working on a steamer on the Great Lakes, and "jerking sodas" in Atlantic City. He worked in boys' camps and with private youth agencies, served as a juvenile probation officer, and worked for the Bureau of Economic Research.

His first writing venture was in collaboration with artist Calvin Bailey on a series of articles on boxers. The articles were sold to New York newspapers. He said his first book for children, *Call Me Charlie*, was written as "a small tribute to the good people who somehow or other succeed in making bad things better." In 1974 he became a lecturer at Appalachian State University. Among his awards are a MacDowell Colony Fellowship and the National Council for the Social Studies Carter G. Woodson Award in 1975.

Bibliography

Call Me Charley. Illustrated by Doris Spiegel. Harper, 1945.

Anchor Man. Illustrated by Doris Spiegel. Harper, 1947.

Room for Randy. Illustrated by Frank Nicholas. Friendship Press, 1957.

Charley Starts from Scratch. Harper, 1958.

Tessie. Illustrated by Harold James. Harper, 1968.

The Sickest Don't Always Die the Quickest. Doubleday, 1971.

The Fourteenth Cadillac. Doubleday, 1972.

Queen of Gospel Singers. Crowell, 1974.

Make a Joyful Noise unto the Lord: The Life of Mahalia Jackson. Crowell, 1974.

Joyce Arkhurst

Augusta Baker

Lerone Bennett, Jr.

Kay Brown

Ashley Bryan. Photograph by
Sally Stone Halvorston.

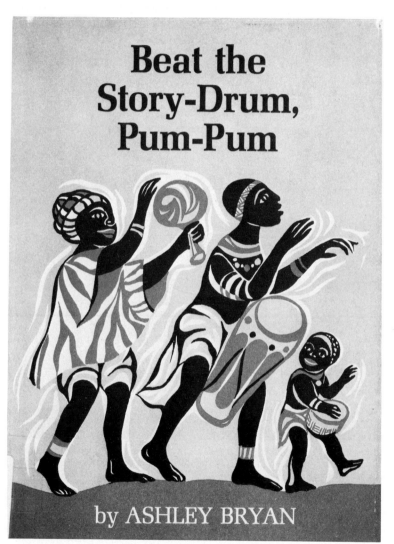

Beat the Story-Drum, Pum-Pum

by ASHLEY BRYAN

Dust jacket for *Beat the Story Drum, Pum Pum*, by Ashley Bryan. Reprinted with permission of Atheneum Publishers, an imprint of Macmillan Publishing Company. Jacket illustration by Ashley Bryan. Copyright © 1980 Ashley Bryan.

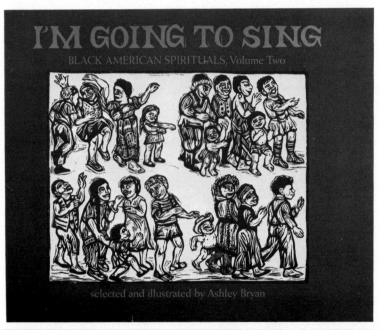

Dust jacket for *I'm Going to Sing: Black American Spirituals, Volume Two*, by Ashley Bryan. Reprinted with permission of Atheneum Publishers, an imprint of Macmillan Publishing Company. Jacket illustration copyright © 1982 Ashley Bryan.

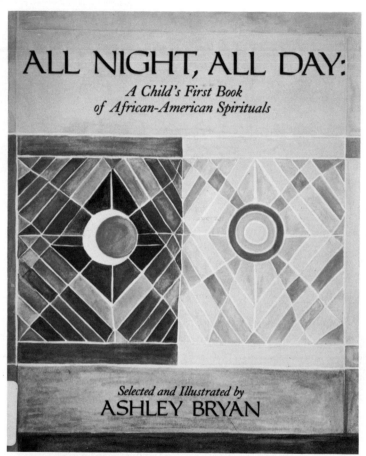

Dust jacket for *All Night, All Day: A Child's First Book of African-American Spirituals*, by Ashley Bryan. Reprinted with permission of Atheneum Publishers, an imprint of Macmillan Publishing Company. Jacket illustration copyright © 1991 Ashley Bryan.

Jeannette Franklin Caines.
Photograph by Al Certa.

Mary Kennedy Carter

Wil Clay

Floyd Donald Cooper, II

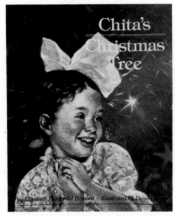

Dust jacket for *Chita's Christmas Tree* by
Elizabeth Fitzgerald Howard, illustrated
by Floyd Cooper.

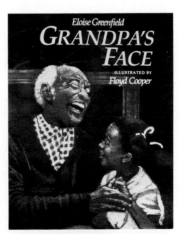

Dust jacket for *Grandpa's Face* by Eloise
Greenfield, illustrated by Floyd Cooper.
Reprinted by permission of Philomel
Books. Illustrations copyright © 1988
by Floyd Cooper.

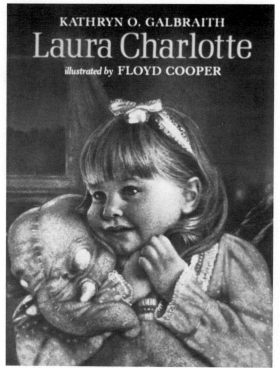

Dust jacket for *Laura Charlotte* by Kathryn O. Galbraith, illustrated by Floyd Cooper.

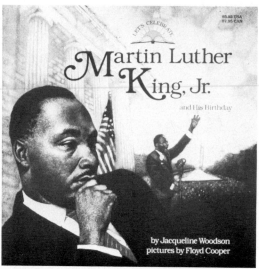

Dust jacket for *Martin Luther King, Jr. and His Birthday* by Jacqueline Woodson, illustration by Floyd Cooper.

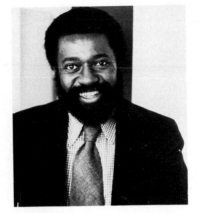

Donald Crews. Photograph by
Chuck Kelton.

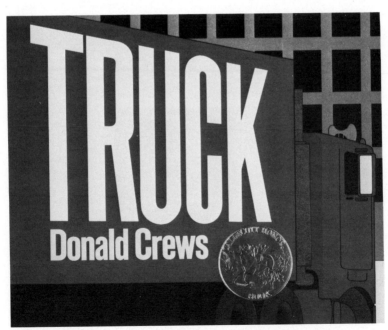

Dust jacket for *Truck* by Donald Crews. Courtesy of Greenwillow Books.

Pat Marie Cummings

Alexis Deveaux

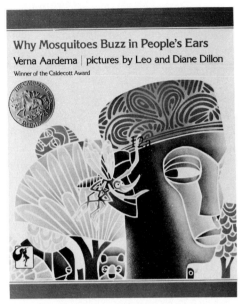

Dust jacket for *Why Mosquitoes Buzz in People's Ears* by Verna Aardema, illustrations by Leo and Diane Dillon.

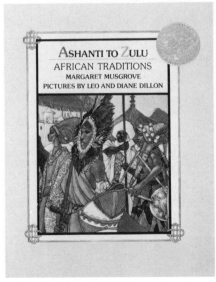

Dust jacket for *Ashanti to Zulu: African Traditions* by Margaret Musgrove, illustrations by Leo and Diane Dillon. Courtesy E.P. Dutton.

Audrey Edwards. From a photograph by Risasi-Zachariah Dais.

Veronica Ellis

Elton Fax

Dust jacket for *Take a Walk in Their Shoes* by Glennette Tilley
Turner, illustrated by Elton C. Fax. Copyright © by Elton C. Fax.
Used by permission of Cobblehill Books, an affiliate of Dutton
Children's Books, a division of Penguin USA Inc.

Thomas Feelings

Dust jackets for *Moja Means One: Swahili Counting Book* and *Jambo Means Hello* by Muriel Feelings. Illustrations by Thomas Feelings. Courtesy E.P. Dutton.

Dust jacket for *To Be a Slave* by Julius Lester, illustrations
by Thomas Feelings. Courtesy E.P. Dutton.

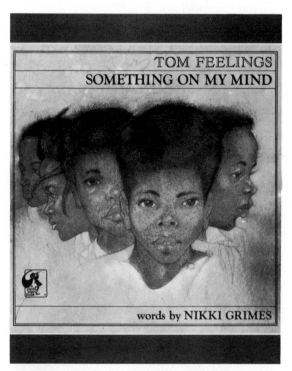

Dust jacket for *Something on My Mind* by Nikki Grimes, illustrations by Thomas Feelings. Courtesy E.P. Dutton.

Valerie R. Flournoy

Bernette G. Ford

George Ford, Jr.

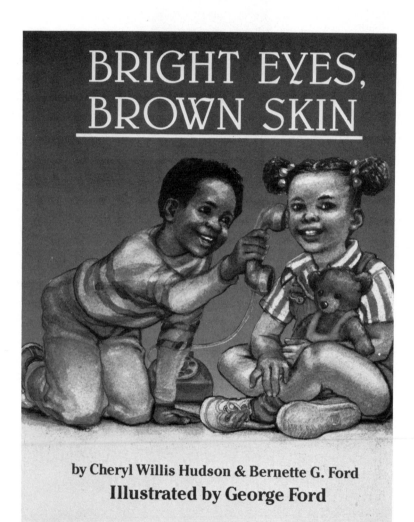

BRIGHT EYES, BROWN SKIN

by Cheryl Willis Hudson & Bernette G. Ford
Illustrated by George Ford

Jan Spivey Gilchrist

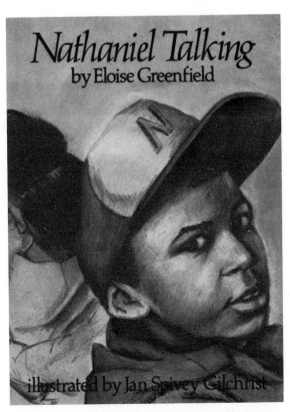

Dust jacket for *Nathaniel Talking* by Eloise Greenfield, illustrated by Jan Spivey Gilchrist. Courtesy of Black Butterfly Children's Books.

Eloise Greenfield. Photograph
by Tony Hawkins.

Rosa Guy

The Ups and Downs
of Carl Davis III

Rosa Guy

Dust jacket for *The Ups and Downs of Carl Davis III* by Rosa Guy. Copyright © 1989. Used by permission of Delacorte Press, a division of Bantam Doubleday Dell Publishing Group, Inc.

Virginia Esther Hamilton. Photograph by
Cox Studios.

Dust jacket for *M.C. Higgins, the Great* by Virginia
Hamilton. Courtesy Macmillan Children's Book Group.

Cheryl Hanna. Photograph by Allan Einhorn/
Modern Images.

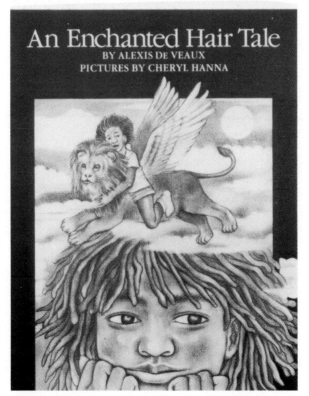

Dust jacket for *An Enchanted Hair Tale* by Alexis Deveaux, illustrated
by Cheryl Hanna.

Joyce Viola Hansen. Photograph by
Austin Hansen.

James S. Haskins. Photograph by George
Gray Photography.

Elizabeth
Fitzgerald Howard

Cheryl Willis Hudson

Wade Hudson

Margo Humphrey. Photograph by
Margaretta Mitchell.

Angela Johnson

Dolores Johnson. Photograph by Elizabeth King.

June Jordan

Julius Lester. Photograph courtesy
Scholastic, Inc.

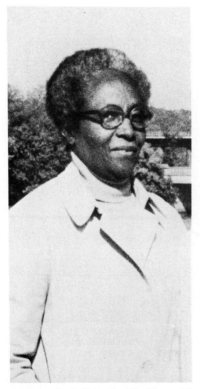
Lessie Jones Little. Photograph by Weston W.
Little.

Dust jacket for *Philip Hall Likes Me. I Reckon Maybe* by Bette Greene, illustrations by Charles Lilly. Courtesy E.P. Dutton.

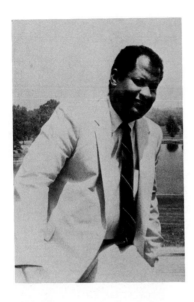

Fredrick McKissack

Patricia C. McKissack. Photograph by Charles
Hawkins, St. Louis.

Phil Mendez

Emily R. Moore

Walter Dean Myers

Ann Petry

Brian Pinkney

Jerry Pinkney

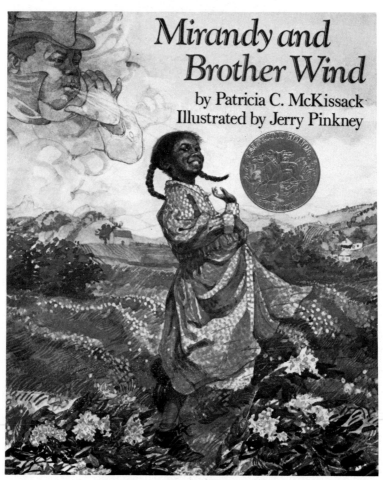

Dust jacket for *Mirandy and Brother Wind* by Patricia C. McKissack, illustrated by Jerry Pinkney. Illustrations copyright © 1988 by Jerry Pinkney. Reprinted by permission of Alfred A. Knopf, Inc.

Dust jacket for *The Patchwork Quilt* by Valerie Flournoy, illustrations by Jerry Pinkney. Courtesy E.P. Dutton.

Dust jacket for *The Tales of Uncle Remus: The Adventures of Brer Rabbit* as told by Julius Lester, illustrations by Jerry Pinkney. Courtesy E.P. Dutton.

James Ransome

Desmond A. Reid

Faith Ringgold. Photograph by C. Love. Courtesy of Bernice Steinbaum Gallery, New York City.

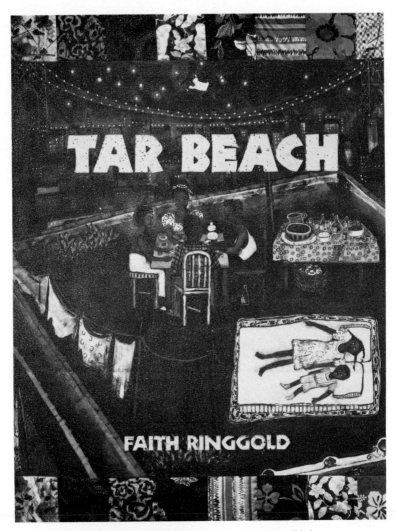

Dust jacket for *Tar Beach* by Faith Ringgold. Courtesy of Crown Publishers.

Dorothy Washington Robinson

Reynold Ruffins

John Steptoe

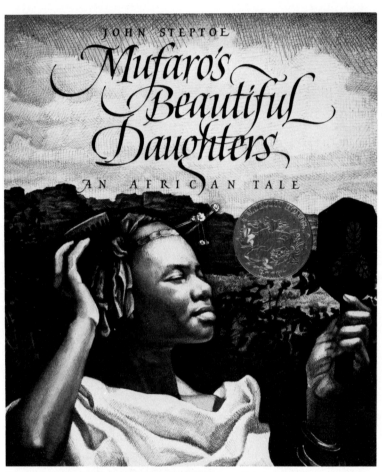

Dust jacket for *Mufaro's Beautiful Daughters: An African Tale* by John Steptoe. Courtesy Lothrop, Lee & Shepard Books. Permission to reprint granted by the Estate of John Steptoe.

Ruth Ann Stewart

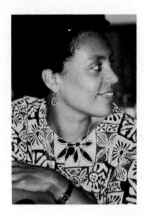

Veronique Tadjo

Eleanora Elaine Tate. Photograph by Zack
Hamlett, III, Positive Images, Inc.

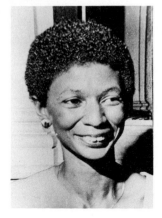

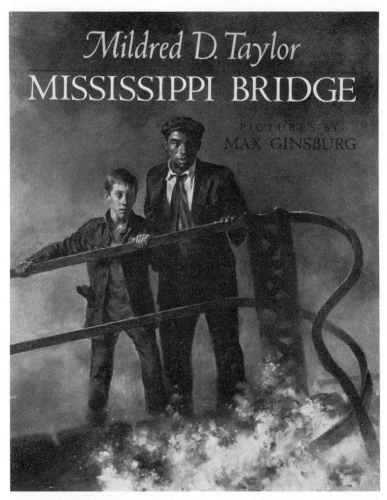

Dust jacket for *Mississippi Bridge* by Mildred Taylor, illustrated by Max Ginsberg. Copyright © 1990. Used by permission of Delacorte Press, a division of Bantam Doubleday Dell Publishing Group, Inc.

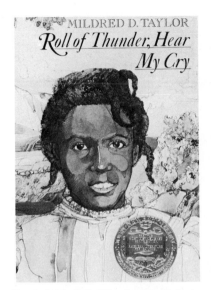

Dust jacket for *Roll of Thunder, Hear My Cry* by
Mildred D. Taylor.

Ianthe Thomas. Photograph
by Jonny S. Buchsbaum.

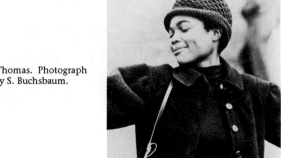

Joyce Carol Thomas

Glennette Tilley Turner

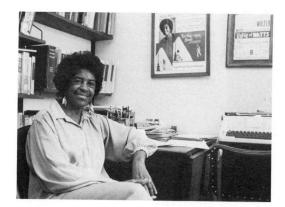

Mildred Walter

Darwin McBeth Walton

Brenda Wilkinson. Photograph
by Archie Hamilton.

Johnneice Marshall Wilson

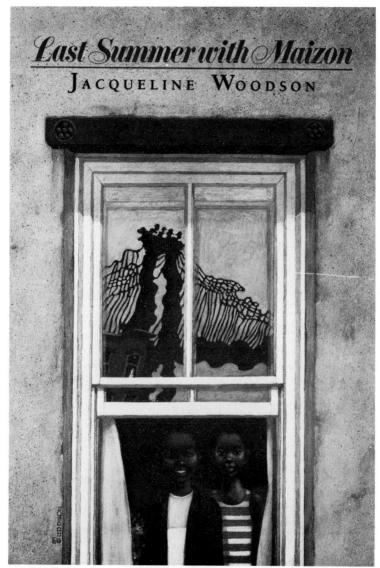

Dust jacket for *Last Summer With Maizon* by Jacqueline Woodson. Copyright © 1990 by Jacqueline Woodson. Used by permission of Delacorte Press, a division of Bantam Doubleday Dell Publishing Group, Inc.

Jacqueline Woodson. Photograph by Hilary Sio.

Camille Yarbrough

JOHNSON, ANGELA (1962–)
Author

Family storytelling has been the overiding influence in my writing. While my book characters aren't actual living beings, they are part of wholes—my family, living and dead.

My childhood was enriched by stories of people, most unknown to me, but usually related. There is such a rich storytelling tradition in the African American culture. It's art, dance, and music all rolled into one. I am lucky to be part of this proud tradition.

Angela Johnson attributes her storytelling skills to her father and grandfather, both of whom frequently told stories to the children in the family. She began writing poetry in Windham High School in Ohio and continued while attending Kent State University. Her first book, *Tell Me a Story, Mama*, is described in a School Library Journal review as a "touching picture book. Both language and art are full of subtle wit and rich emotion. . . ." The story revolves around the conversations a small child has with her mother about their family history.

Johnson feels there should be more black-oriented literature for children and senses the need for black children to see their own images in books. She has placed her own Aunt Rosetta as a character in her book *Tell Me a Story, Mama*.

She is a former Vista volunteer in Ravenna at the King-Kennedy Community Center and a volunteer at the Kent Head Start Program. She is single and has worked as a nanny for four years in Kent. She now shares her home with a woman who has two small children.

She was born in Tuskegee, Alabama, and is currently a resident of Kent, Ohio.

Her book *When I Am Old with You* won the 1991 Coretta Scott King Honor Book Award.

Bibliography

Tell Me a Story, Mama. Illustrated by David Soman. Orchard, 1989.

Do Like Kyla. Illustrated by James E. Ransome. Richard Jackson Books. Orchard, 1990.

When I Am Old with You. Illustrated by David Soman. Richard Jackson Books. Orchard, 1990.

One of Three. Illustrated by David Soman. Orchard, 1991.

JOHNSON, DOLORES
Author/Illustrator

When I was young, I knew I could draw, but I didn't think I was an artist. You see, I had an artist living in the house with me, my older brother, Billy, and I knew I wasn't in his league.

I went to art school also but upon graduating I floundered about. . . . I always sought a way to satisfy my creative nature by working at home at night as a potter, making stained glass windows, and eventually painting in oils and water colors.

A friend happened to see some of my writing and my painting and suggested that I might consider creating children's books. This idea was a brand new concept to me.

I hadn't come from what I would call a story-telling family (Dad did not sit me on his knee to tell me stories bout Great Aunt Minnie), nor did I have a lot of picture books around me as a child. But I did feel children's books would be a perfect outlet for my artwork and my writing. Also, I love children and I love books.

I welcome the opportunity to write and illustrate books because it is a wonderful means to communicate with the most important segment of our society—the children. I like to write about the basic issues that are critical to the typical child's life—leaving home for school for the first time, being left with a babysitter, coming home to an empty house, performing in a school play, etc. It's been a thousand years since I felt these fears personally, but I can still remember the intensity of experience brought about by these chapters in my life. Perhaps, through my writing and artwork, I can help a young child find comfort, maybe even a laugh and hopefully a solution to some of the problems that trouble them.

I like to use black models in my illustrations as well as children from different cultures because I like all children to feel they are participants in this culture and society. If a black or a latino child never sees him- or herself in a book (as I never saw myself as a child in picture book), that child begins to question their worth and place in this country. I try to write about the universal joys and fears of all children, and I hope that all children might find something enjoyable in my work.

I love children's books. There are books written by certain authors or illustrated by certain artists that I have enjoyed again and again, even as an adult. I realize that I, as

an artist, have a tremendous responsibility the children who read my books. I hope that they might find as much pleasure reading my books as I have writing them.

And, by the way, my brother is still a very good artist.

She is a graduate of Boston University, finishing college in 1971 with a bachelor of fine arts. She was born in New Britain, Connecticut, and now resides in Inglewood, California.

Bibliography

Jenny by Beth P. Wilson. Macmillan, 1990.

What Will My Mommy Do When I'm At School? Macmillan, 1990.

What Kind of Baby-Sitter Is This? Macmillan, 1991.

The Best Bug to Be. Macmillan, 1992.

Your Dad Was Just Like You. Macmillan, 1992.

JOHNSON, HERSCHEL LEE (1948–)
Author

> Children's books seem to provide opportunities for stories with elements of fantasy. This particular book made me aware that there were few books for African American children in the literature for children. When I was asked to work with Romare Bearden, it was the best opportunity.

Johnson was born in Birmingham, Alabama. A graduate of Dartmouth College in 1970, he later attended the Columbia University School of Journalism. He was associate editor of *Ebony* magazine and a freelance writer from 1974 to 1976 for *Black Enterprise* magazine where he had worked as assistant and associate editor from 1972 to 1974. In 1971–1972 he was assistant editor and researcher at *Newsweek*.

His poetry has been published in *Young Black Poets Anthology* and in *Blackout*, a literary magazine. He currently does public relations work for AT&T in New York City.

Bibliography

A Visit to the Country. Illustrated by Romare Bearden. Harper, 1989.

JOHNSON, JAMES WELDON (1871–1938)
Author

James Weldon Johnson was born in 1871 in Jacksonville, Florida, where he attended city schools. After graduation from Atlanta University he became an elementary school principal, developing the school program until it became a high school. He then received a law degree and practiced law in Florida.

He and his brother J. Rosamond Johnson moved to New York and worked together on writing songs and musicals. During this time Johnson attended Columbia University for graduate study in drama and literature.

Johnson is probably best known for the "national Negro anthem," "Lift Every Voice and Sing." He wrote the words and his brother, the music. While serving as United States consul in Venezuela and Nicaragua he wrote *The Autobiography of an Ex-Coloured Man*. He contributed articles to magazines, translated the libretto of Spanish opera *Coyescas*, and served for many years as secretary and field secretary of the NAACP. He was one of the primary shapers of the artistic movement called the Harlem Renaissance and was awarded the Spingarn Medal in 1925. Johnson died in a tragic accident in 1938.

Bibliography

God's Trombones. Illustrated by Aaron Douglas. Viking, 1927.

Along This Way. Viking/Penguin. 1968.

Lift Every Voice and Sing with J. Rosamond Johnson. Illustrated by Mozelle Thompson. Hawthorne, 1970.

JORDAN, JUNE [JUNE MEYER] (1936–)
Author

Jordan was born in Harlem and grew up in the Bedford-Stuyvesant section of Brooklyn. She attended Barnard College and the University of Chicago and then taught English at Connecticut College, City College, City University of New York, Sarah Lawrence College, and the State University of New York (SUNY) at Stony Brook.

Among her awards are a Rockefeller Foundation Fellowship in creative writing, the Rome Prize Fellowship in Environmental Design, 1970–1971, and a C.A.P.S. grant in poetry. Her publications include essays, poetry, newspaper articles, and books for young people. Her work has appeared in the *New York Times*, *Partisan Review*, *Village Voice*, and *The Nation*. She has worked in films, with Mobilization for Youth, and as co-director of The Voice of the Children, Inc., and its writers' workshop. *His Own Where* was a National Book Award finalist and an American Library Association Best Book for young adults.

In 1982 Jordan was awarded a National Endowment of the Arts Fellowship in poetry, in 1985 a New York Foundation of the Arts Fellowship and, subsequently, an award from the Massachusetts Council on the Arts in Contemporary Arts. In 1986 she received an achievement award for national reporting from the National Association of Black Journalists.

Jordan has been associate professor of English at SUNY at Stony Brook from 1982 to 1987, and a director of its creative writing program. Since 1989 she has been at the University of California in Berkeley as professor of Afro-American studies and professor of English.

She is a member of several organizations including the Center for Constitutional Rights, the New York Foundation of the Arts (where she serves on the board of governors), the Nicaraguan Culture Alliance (where

she is on the board of directors). She was married and has one son.

Bibliography

Who Look at Me. Crowell, 1969.

The Voice of the Children. Collected by June Jordan and Terri Bush. Holt, 1970.

His Own Where. Crowell, 1971.

Fannie Lou Hamer. Crowell, 1972.

New Life: New Room. Crowell, 1975.

Kimako's Story. Houghton, 1981.

KIRKPATRICK, OLIVER AUSTIN [JOHN CANOE] (1911–1988)
Author

The author is also known by his pseudonym, John Canoe. He was born and educated in Jamaica. After coming to the United States he attended New York University, the New School for Social Research, and Columbia University, where he obtained his master's degree in library science.

Kirkpatrick was a columnist and sports editor for the *Jamaica Standard* and a newscaster on radio Jamaica ZQI before working as a librarian in the New York Public Library and a supervising librarian in the Brooklyn Public Library, from which he retired. He received the Joyce Kilmer award from New York University for creative writing. He lived in Brooklyn before his death in 1988.

Bibliography

Naja the Snake and Magnus the Mongoose. Doubleday, 1970.

LAWRENCE, JACOB (1917–)
Illustrator

One of the most outstanding contemporary painters, Lawrence has been called "the nation's foremost Negro painter." His work has been compared favorably with that of Picasso, Daumier, Orozco, and especially Hogarth.

He was born in Atlantic City, New Jersey, on September 17, 1917, but moved when he was two years old with his parents to Easton, Pennsylvania, where the family was abandoned by his father. His mother later moved the family to Philadelphia and then to New York when Lawrence was twelve.

Lawrence studied at the American Artists School in New York on a full scholarship. His spare time was spent at the 135th Street branch of the New York Public Library and at the Schomburg Collection to gather material for a pictorial biography of Frederick Douglass. In 1940 he received a Rosenwald Fellowship to research southern migrants in the North after World War I. His Rosenwald Foundation grant of 1941–1942 enabled him to produce his "Life of John Brown" with a series of twenty-two paintings. A Guggenheim Fellowship in 1945 helped him produce, in 1947, fourteen paintings of World War II. The United States Coast Guard Archives houses his World War II pictures. His 1973 George Washington Bush series bears the caption: "Thank God All-Mighty, home at last!"

His style, described as being a series of large flat forms, with "no depth, and no details," is known for the use of pure colors: blues, reds, yellows. Each picture has a title so that the series in sequence resembles a story's script.

Bibliography

Harriet and the Promised Land. Simon & Schuster, 1968.

LESTER, JULIUS (1939–)
Author

The author was born in St. Louis. His family moved to Kansas City and then to Nashville during his early adolescence. Lester earned his bachelor's degree in English at Fisk University. He attributes his interest in southern rural traditions and black folkfore to his father, a Methodist minister and a good storyteller.

Lester has had a varied work experience. He has been a social services investigator, folk singer, guitar teacher, and teacher of black history at the New School for Social Research from 1968 to1970. He also hosted a talk show on WBAI-FM radio in New York from 1969 to 1972. In 1991 he was a professor of black studies at the University of Massachusetts.

His political activities include experience in the late 1960s as a field secretary and head of the photo department, Student Non-Violent Coordinating Committee. In 1967 he took photographs of North Vietnam to show the effects of United States bombing there and also attended the Organization of Latin American Solidarity Conference in Cuba with Stokeley Carmichael.

The critical responses from children to his first children's book, *To Be a Slave*, convinced him of the difficulty in writing for these readers. As a father of two children, he felt the need to write the sort of books unavailable during his own childhood. Lester has written books for adults, and his writings have also appeared in newspapers and journals such as the *Village Voice*, *Ebony*, *New York Free Press*, *New York Times Book Review*, *Broadside*, and *Parents' Choice*. He has written poetry and edited poetry anthologies. His interest in music shows in his work with Pete Seeger: *The Twelve-Stringed Guitar as Played by Leadbelly*.

To Be a Slave was a Newbery Honor Book in 1969 and winner of the 1968 Nancy Bloch Award. *Long Journey Home* in 1972 and *Black Folktales* in 1969 were

on the *New York Times* list of outstanding books of the year. *Long Journey Home* was nominated for a National Book Award in 1973.

Lester lives in Amherst, Massachusetts, with his wife and four children.

Bibliography

To Be a Slave. Edited by Julius Lester. Illustrated by Tom Feelings. Dial, 1968.

The Knee-High Man and Other Tales. Illustrated by Ralph Pinto. Dial, 1972.

Long Journey Home: Stories from Black History. Dial, 1972.

This Strange New Feeling. Dial, 1982.

The Tales of Uncle Remus: The Adventures of Brer Rabbit. Volume I. Illustrated by Jerry Pinkney. Dial, 1987.

More Tales of Uncle Remus: Further Adventures of Brer Rabbit, His Friends, Enemies and Others. Illustrated by Jerry Pinkney. Dial, 1988.

How Many Spots Does a Leopard Have? Illustrated by David Shannon. Scholastic, 1989.

Further Tales of Uncle Remus: The Misadventures of Brer Rabbit, Brer Fox, Brer Wolf, the Doodang and all the Other Creatures with Phyllis J. Fogelman, eds. Illustrated by Jerry Pinkney. Doubleday, 1990.

Falling Pieces of the Broken Sky. Illustrated by Jerry Pinkney. Arcade, 1990.

LILLY, CHARLES
Illustrator

The illustrator of *Philip Hall Likes Me* studied in New York City at the School of Visual Arts, where he also taught a painting class. His work has appeared in magazines and as book jacket illustrations, and his art has been recognized by awards of merit from the Society of Illustrators, the Art Directors Club, and Publication Designers.

Bibliography

Mukasa by John Nagenda. Macmillan, 1973.

Growin' by Nikki Grimes. Dial, 1977.

Philip Hall Likes Me, I Reckon Maybe by Bette Greene. Dial, 1977

Escape from Slavery: Five Journeys to Freedom by Doreen Rappaport. HarperCollins, 1991.

LITTLE, LESSIE JONES (1906–1986)
Author

Lessie Little's daughter, children's author Eloise Greenfield, has noted that her mother had a special love for people and for the arts and enjoyed bringing these together through her writing. Although Little entered this field late in her life (she was almost seventy), she was diligent in studying the craft and took seriously what she saw as her responsibility to pass on to children messages of truth and hope.

Little was born in Parmele, North Carolina. She was a 1924 graduate of Higgs Roanoke Seminary, a high school in Parmele. After graduation she began teaching in her home state and two years later married her childhood sweetheart, Weston W. Little, Sr. They moved to Washington, D.C., in 1929 and later became parents of five children (Wilbur, Eloise, Gerald, Vedie, and Vera), grandparents of fifteen, and great-grandparents of seven.

As a young mother, Little studied sewing and became a skilled seamstress. She also played the piano and painted. Her work with children in the neighborhood involved presenting them in community programs and at church. In 1972 after her retirement as a government clerk, she developed a Harriet Tubman crossword puzzle, which appeared in *Ebony Jr.*'s June/July 1973 issue. This experience became the stimulus for writing and she began to attend writing workshops. Her own book of poetry *Love: A Lamp Unto My Feet* was published in 1982.

Among her awards during her brief writing career were the Boston Globe-Horn Book honor award in 1980 for *Childtimes*, which she co-authored with her daughter Eloise Greenfield, and the 1988 Parents' Choice Award for *Children of Long Ago*.

Her memberships included a 40-year membership at the Israel Metropolitan C.M.E. Church in Washington, D.C., and the Young at Heart Club (a senior

citizen's organization), Washington, D.C. She died leaving several unpublished manuscripts—picture books and poetry for children and a novel for adults.

Bibliography

I Can Do It By Myself with Eloise Greenfield. Illustrated by Carole Byard. Crowell, 1978.

Childtimes: A Three-Generation Memoir with Eloise Greenfield. Illustrated by Jerry Pinkney. Crowell, 1979.

Children of Long Ago. Illustrated by Jan Spivey Gilchrist. Philomel, 1988.

LLOYD, ERROL (1943–)
Author/Illustrator

Lloyd's interest in art started at about age sixteen after he had decided on a legal career. Lloyd was born in Jamaica and attended Munro College, Jamaica; London University; and Council of Education in London. In 1964 Lloyd started to study law, but his interest in art outweighed this pursuit and he never completed his studies. His illustrations for *My Brother Sean* were commended for the Kate Greenaway Medal in England in 1977.

Bibliography

Shawn Goes to School by Petronella Breinburg. Crowell, 1973.

Shawn's Red Bike by Petronella Breinburg. Crowell, 1976.

Nini at Carnival. Crowell, 1978.

LYNCH, LORENZO (1932–)
Illustrator

The artist took a correspondence course from Art Instruction, Inc., Minneapolis, from 1946 to 1950. He then attended the Art Students League and the School of Visual Arts in New York City. He worked as an artist with Fisher Advertising in Brooklyn, at Olivetti in New York City, Martin's Department Store in Brooklyn, and New York's Annivette Studios. He lives in Brooklyn, New York.

Bibliography

The Hot Dog Man. Bobbs-Merrill, 1970.

The Black Is Beautiful Beauty Book by Melba Miller. Prentice-Hall, 1974.

Big Sister Tells Me That I'm Black by Arnold Adoff. Holt, 1976.

MCCANNON, DINDGA (1947–)
Illustrator

McCannon was born in Harlem and studied at the Art Students League and the City University of New York. At seventeen she exhibited her work in a one-woman show, followed by other exhibitions at the PAX Gallery, as a participant in Genesis II, the Black Expo, and the Harlem Outdoor Art Show. She was co-founder of a black women's art collective, Where We At. McCannon has also worked as a dress designer, teacher of print making, and jewelry designer. She both illustrated and wrote the text for *Peaches*, her first children's book as an author.

Bibliography

Omar at Christmas by Edgar White. Lothrop, 1973.

Sati the Rastifarian by Edgar White. Lothrop, 1973.

Children of Night by Edgar White. Lothrop, 1974.

Peaches. Lothrop, 1974.

McKissack, Fredrick (1939–)
Author

> If you don't know the stories and lore of your people then
> it is difficult to participate in the culture.

McKissack, a civil engineer, owned his own construction company for many years. Now, he feels his writing "builds bridges with books." He comes from a long line of builders. His great-grandfather Moses McKissack was the first licensed black architect in the state of Tennessee and founder of a company that bore his name as partner. His grandfather was one of the first African American builders known particularly for his design of doors. His father, Louis Winter McKissack, was also an architect.

McKissack attended Tennessee State University and obtained his bachelor of science in civil engineering in 1964. He is a member of the African Methodist Episcopal Church, where he is a steward on the church board and a member of the male chorus. He also belongs to the National Writers Guild, the Society of Children's Book Writers, and is co-owner of All-Writing Services with his wife Patricia.

He has shared honors with his wife for the book *Light's Out Christopher*, which won the C.S. Lewis Silver Award, a Jane Addams Peace Award for *Abram, Abram, Where Are We Going?*, and the Tennessee Book Selection Volunteer Committee Children's Award.

The McKissacks have also produced a series of easy readers known as Rookie Readers; titles include *Messy Bessey . . .* and *Bugs.*

In 1989 they won the Coretta Scott King Award for *A Long Hard Journey: The Story of the Pullman Porter.* [*See also* Patricia C. McKissack.]

Bibliography

Abram, Abram, Where Are We Going? with Patricia C. McKissack. David Cook, 1984.

Lights Out Christopher with Patricia C. McKissack. Illustrated by Bartholomew. Augusburg, 1984.

The Civil Rights Movement in America from 1865 to the Present with Patricia C. McKissack. Children's Press, 1987.

Frederick Douglass: The Black Lion with Patricia C. McKissack. Children's Press, 1987.

Messy Bessey Share-a-Story Unit with Patricia C. McKissack. Illustrated by Richard Hackney. (A Big Book.) Children's Press, 1988.

A Long Hard Journey: The Story of the Pullman Car Porter with Patricia C. McKissack. Walker, 1989.

God Made Something Wonderful with Patricia McKissack. Illustrated by Ching. Augusburg, 1989.

W.E.B. Du Bois with Patricia C. McKissack. Watts, 1990.

McKissack, Patricia [L'Ann] C. [Arwell] (1944–)
Author

> Good books—fiction and nonfiction—written for, by, and about African Americans are needed if we are to help young readers develop a healthy self-image and an open attitude about other cultures different from their own. That is my goal. To reach it, however, I begin by writing an *appealing story*. When youngsters have an enjoyable reading experience, they are most likely to choose a similar book . . . and another. By providing interesting and lively written materials for children the above goal can be achieved.

The author was born in Nashville, Tennessee, and married writer Fredrick L. McKissack. They are the parents of three boys—a set of twins and Fredrick Jr.

McKissack attended Tennessee Agricultural & Industrial State University, now Tennessee State University, where she obtained her bachelor of arts degree in 1964. She earned her master of arts in 1975 from Webster University in St. Louis. From 1968 to 1975 she worked as a junior high school teacher in Kirkwood, Missouri, and in 1975 was a part-time instructor in English at Forest Park College in St. Louis. In 1976 she was a children's book editor at the Concordia Publishing House and in 1984 at the Institute of Children's Literature, both in St. Louis.

By 1978 she had become co-owner of All-Writing Services and was an instructor of children's literature at the University of Missouri.

McKissack has been a writer for a preschool series, "L Is for Wishing," broadcast by KWMU Radio from 1975 to 1977. She has written radio and TV scripts and been a contributor to the magazines *Friend*, *Happy Times*, and *Evangelizing Today's Child*.

She serves as an educational consultant in minority literature. She is a lecturer in conjunction with the McKissack Center for Minority Children's Literature at Lindenwood College–Butler Library, St. Charles, Missouri.

Among her awards are the Helen Keating Ott Award from the National Church and Synagogue Librarians Association in 1980 for her editorial work at Concordia Publishing House, the C.S. Lewis Silver award from *Christian School Magazine* in 1984 for *It's the Truth, Christopher* and *Abram, Abram, Where Are We Going?*

The book, *Long Hard Journey*, co-authored with husband Fredrick, was the 1989 winner of the Coretta Scott King Award. *Mirandy and Brother Wind* was a Caldecott Honor book and was also cited as an Honor Book for the 1988 Coretta Scott King Award.

Her memberships include Alpha Kappa Alpha Sorority, Tennessee State Alumni, the Authors' Guild, and the Society for Children's Book Writers. [*See also* Fredrick McKissack]

Bibliography

Michael Jackson, Superstar. Children's Press, 1984.

Paul Laurence Dunbar: A Poet to Remember. Children's Press, 1984.

It's the Truth, Christopher. Illustrated by Bartholomew. Augusburg, 1984.

Flossie and the Fox. Illustrated by Rachel Isadora. Dial, 1986.

Mirandy and Brother Wind. Illustrated by Jerry Pinkney. Knopf, 1988.

Jesse Jackson: A Biography. Scholastic, 1989.

Nettie Jo's Friend. Illustrated by Scott Cook. Knopf, 1989.

A Long Hard Journey: The Story of the Pullman Car Porter with Fredrick McKissack. Walker, 1989.

James Weldon Johnson: Lift Every Voice and Sing. Children's, 1990.

Christmas in the Big House, Christmas in the Quarters. Scholastic, in press.

MADHUBUTI, SAFISHA (1935–)
[JOHARI M. AMINI]
[KUNJUFU, JOHARI M. AMINI]
Author

Formerly, Jewel Latimore, Safisha Madhubuti, changed her name legally to Johari M. Amini. The daughter of a clergyman, she is married to Haki Madhubuti (Don L. Lee), the poet and publisher, and was a co-founder of the Third World Press. She and her husband are parents of two sons and a daughter.

Madhubuti attended Chicago City College, from which she received an associate of arts degree, and later, the University of Chicago, where she obtained her bachelor of arts degree in 1970.

She has worked as an editor for the Third World Press, contributed numerous articles to the periodicals *Black World* and *Negro Digest*. She has also been assistant editor for the *Black Books Bulletin*. Her work appears in over a dozen anthologies.

From 1965 to 1966 she worked at the Chicago City College. For the period 1970–1972 she was instructor in psychology and a lecturer in black literature at the college.

Her memberships include the Institute of Positive Education, the African Heritage Studies Association, and the Organization of Black American Culture.

Since 1974 she has been the director of the successful New Concept Development Center in Chicago, an "affirmative African American educational institution."

Bibliography

The Story of Kwanzaa. Illustrated by N. DePillars. Third World Press, 1989.

MAGUBANE, PETER (1932–)
Illustrator

Photographer Magubane was born in Johannesburg, South Africa. He started his career as a photographer in 1956 on the magazine *Drum* and was a staff member in 1956 of the *Rand Daily Mail*, a Johannesburg newspaper. For more than twenty years he was the only major black South African news photographer. His experiences, recorded in *Magubane's South Africa*, portray his arrests, banning orders, solitary confinement, and other experiences under the apartheid system. He still has a home in Dupkloof, a section of the black township of Soweto outside Johannesburg.

Bibliography

Black Child. Knopf, 1982.

MATHIS, SHARON BELL (1937–)
Author

Mathis was born in Atlantic City, New Jersey, the daughter of John Willie and Alic Mary [Frazier] Bell. She taught parochial school in Washington, D.C., was a special education teacher, and was writer-in-residence at Howard University. As a member of the D.C. Black Writers Workshop in the early 1970s, she was designated "writer-in-charge" of the children's literature division. Mathis has a bachelor's degree from Morgan State College and a master's in library science from Catholic University of America. Her interviews of children for *Ebony Jr.* magazine are well known. She has been a member of the Black Women's Community Development Foundation since 1973 and is currently a media specialist in the Friendship Educational Center.

Sidewalk Story was the winning manuscript in the Council of Interracial Books for Children writers' contest in 1970. *Teacup Full of Roses* was an American Library Association Notable Book; and *The Hundred Penny Box*, a Newbery Honor Book, now available as a Puffin paperback, was the basis for a children's film. She received a fellowship from Wesleyan University and recognition from the Weekly Readers Book Club and the Bread Loaf Writer's Conference. She won the Coretta Scott King Award in 1974 for *Ray Charles* and the Wallace Johnson Memorial Foundation Award in 1984 for "outstanding contributions to the literary arts." Her memberships include the D.C. Association of School Librarians and Reading is Fundamental.

She lives in Maryland, close to Washington, D.C.

Bibliography

Sidewalk Story. Viking, 1971.

Ray Charles. Crowell, 1973.

Listen for the Fig Tree. Viking, 1974.

The Hundred Penny Box. Viking, 1975.

Teacup Full of Roses. Viking, 1982.

MEDEARIS, ANGELA SHELF [ANN SHELF] (1956–)
Author

> I love introducing children all over the world to all the different aspects of African American history and culture. I love picture books because it is a challenge to convey complex ideas in a simple form for children. I really love it when I can factually and vividly cover years of history in a 32- or 48-page book, hold a child's attention, and teach them something important.
>
> Picturebooks are a child's first step into a lifetime of reading. That's why I feel that my job is important. I want to write about history in such an interesting and exciting way that the memory of reading my book and the information it contained about a particular historical event will linger with them for a lifetime.

Medearis was born in Hampton, Virginia, and attended Southwest Texas University for one year. She has since published one nonfiction book for children based on her mother's life during the depression: *Picking Peas for a Penny*, written in rhyme. The sequel, *Dancing with the Indians*, was published in the fall of 1991.

She has scheduled for publication in 1992 and 1993 an adaptation of *Treemonisha*, Scott Joplin's folk opera; *The Zebra Riding Cowboy*, an adaptation of an old cowboy song; and *Poppa's New Pants*, an adaptation of a family story.

Medearis is a project director for Book Boosters, a multicultural, multiethnic reading motivational/tutorial program designed for elementary students in the Austin (Texas) Independent School District. She is also the producer of the Children's Radio Bookmobile, a weekly 15-minute nationwide radio program devoted to children's literature focusing on a wide range of topics and featuring writers of all ethnic backgrounds. In addition, she is curator of two African American history exhibits for the George Washington Carver

Museum in Austin—"Buffalo Soldiers: The Art of Burl Washington," and "Black Life in the 1950s: The Photography of Benny Joseph and R.C. Hickman."

She is a member of the Society of Children's Book Writers, the Texas Library Association, the Texas State Reading Association, and the American Black Book Writers Association. She and her husband, Michael Rene Medearis, and daughter live in Austin, Texas.

Bibliography

Picking Peas for a Penny. Illustrated by Charles Shaw. State House, 1990.

Dancing with the Indians. Illustrated by Sam Byrd. Holiday, 1991.

Treemonisha. Holt, 1992.

Zebra Riding Cowboy. Holt, 1992.

Poppa's New Pants. Holt, 1992.

From Africa to America: African American History for Children. Macmillan, 1992.

Annie's Gift. Just Us Books, in press.

The Christmas Riddle. Lodestar/Penguin, in press.

MENDEZ, PHIL (1947–)
Author

In the animation business, Phil Mendez is known as an artist. He has created cartoons for the Walt Disney Studios, Marvel Productions, Disney's subsidiary, WED, Hanna-Barbera Productions, Chuck Jones, and Pantomime Pictures, among others. He was born in Bridgeport, Connecticut, and he and his wife Karen live in Sierra Madre, California, with their daughter.

Phil Mendez Productions is his own studio, where he and his wife write and conceive ideas for children's books. Mendez has been an art director for commercial TV accounts such as Cocoa Puffs and Cheerios; directed accounts for the 1982 World Olympics; has created two animated shows for NBC Saturday morning cartoons, "Kissyfur" and "Foofur"; and has designed toys, greeting cards, and some fine arts lithographs.

His hobby is painting in watercolors and oils.

Bibliography

The Black Snowman. Illustrated by Carole Byard. Scholastic, 1987.

MERIWETHER, LOUISE M. (1923–)
Author

Meriwether was born in Havestraw, New York, received her bachelor's degree from New York University and, in 1965, received her master's from the University of California at Los Angeles. She has worked as a story analyst at Universal Studios in California, a legal secretary, and a freelance writer, publishing articles and short stories in magazines. Her memberships include the Watts Writers' Workshop, the Authors Guild, and Harlem Writers Guild.

Bibliography

The Freedom Ship of Robert Small. Prentice-Hall, 1971.

Don't Ride the Bus on Monday: The Rosa Parks Story. Prentice-Hall, 1973.

MILLENDER, DHARATHULA [HOOD] (1920–)
Author

Millender, librarian, teacher, and author, was born in Terre Haute, Indiana. She graduated from Indiana State University and has completed additional study at Indiana and Purdue universities and at the Catholic University of America.

She was a teacher and librarian in South Carolina and Maryland, a reference assistant at the Library of Congress, a librarian at a military reservation, a junior high school librarian in Baltimore and Gary, Indiana. During 1962–1964 and 1966–1967 she chaired Negro History Week Observance in Gary. She wrote the daily newspaper column "Yesterday in Gary," edited the *Gary Crusader*, and contributed to *Education and Changing Education*. She has memberships in the American Federation of Teachers, Negro Cultural Achievement Committee, Indiana School Library Association, Indiana State Teachers Association, Alpha Kappa Alpha, and the NAACP.

Bibliography

Cripus Attucks, Boy of Valor. Bobbs-Merrill, 1965.

Martin Luther King, Jr., Boy with a Dream. Bobbs-Merrill, 1969.

Louis Armstrong, Young Music Maker. Bobbs-Merrill, 1972.

MILLER, DON (1923–)
Illustrator

The artist was born in Jamaica and grew up in Montclair, New Jersey. He obtained a certificate in art from Cooper Union in 1949 and also attended the New School for Social Research, both in New York City. He has illustrated more than thirty books, magazine articles, and film strips. His art has been exhibited at New York's Museum of Natural History in the exhibit "The Children of Africa." His memberships include the National Conference of Artists and the Society of Illustrators.

Bibliography

The Black BC's. Dutton, 1972.

Langston Hughes, American Poet by Alice Walker. Crowell, 1974.

A Bicycle from Bridgetown by Dawn Thomas. McGraw-Hill, 1975.

The Creoles of Color by James Haskins. Crowell, 1975.

Jocko: A Legend of the American Revolution by Earl Koger. Prentice-Hall, 1976.

MOORE, CARMAN LEROY (1936–)
Author

Born in Lorain, Ohio, the composer received his bachelor's degree from Ohio State University and his master' from Julliard School of Music. He was an assistant professor of music at Yale University and Manhattanville College, a record reviewer and columnist for the Sunday *New York Times*, a music critic for the *Village Voice* and the *Saturday Review*, and a columnist for *Essence* and *Vogue* magazines. Moore was founder and secretary-treasurer of the Society of Black Composers. The San Francisco Symphony Orchestra commissioned his composition "Gospel Fuse," and the New York Philharmonic Orchestra commissioned "Wildfires and Field Songs."

Bibliography

Somebody's Angel Child: The Story of Bessie Smith. Crowell, 1969.

MOORE, EMILY R. (1948-)
Author

Emily Moore was born in New York City and educated in city schools. At City College of New York she majored in Russian and earned her bachelor's degree, graduating cum laude. She earned her master's degree from Columbia University's Teachers College. Her then unpublished manuscript, "Letters to a Friend on a Brown Paper Bag," was declared a winner of the Council on Interracial Books for Children's seventh annual contest.

She received her master's degree in English from C.W. Post in 1987 and is currently studying for her doctorate at the City University of New York Graduate Center. Moore is an English teacher in a Queens Village high school in New York. Her memberships include the Society of Children's Book Writers, the Modern Language Association, National Council of Teachers of English, and the Authors' Guild.

Bibliography

Something to Count On. Dutton, 1980.

Just My Luck. Dutton, 1982.

Whose Side Are You On? Farrar, 1988. Sunburst/Paperback, 1990.

MUSGROVE, MARGARET [WYNKOOP] (1943-)
Author

Musgrove was born in New Britain, Connecticut, where she attended the local schools. She is a graduate of the University of Connecticut and Central Connecticut State College, where she received her master's degree. She has a Ph.D. in education from the University of Massachusetts.

The author has lived in Accra, Ghana. She has been an English high school teacher in Hartford, Connecticut, a counselor and teacher at Berkshire Community College in Pittsfield, Massachusetts, and director of Middle College. She is a member of the Society of Children's Book Writers and the League of Women Voters. Her book *Ashanti to Zulu: African Traditions* was a Caldecott winner.

A mother of two children, Musgrove now lives in Baltimore.

Bibliography

Ashanti to Zulu: African Traditions. Illustrated by Leo and Diane Dillon. Dial, 1977.

MYERS, WALTER DEAN (1937-)
Author

In a 1986 article entitled "I Actually Thought We Would Revolutionize the Industry" in the *New York Times*, Walter Dean Myers had the following to say about his writing:

> I write books for children, filled with the images I've accumulated over the years, with stories I've heard from my father and grandfather. Many take place in the Harlem of my youth. The names of boyhood friends—Binky, Light Billy, Clyde—creep into the stories, and memories of them and of summer days playing endless games of stoopball next to the Church of the Master on Morningside Avenue keep the stories ever alive for me. I'm drawn to the eternal promise of childhood and the flair of the young for capturing the essence of life.

Myers was born in Martinsburg, West Virginia. He speaks of his adoptive parents fondly; the Dean family adopted him informally after his mother's death. He attended City College in New York and received his bachelor's degree in communications from Empire State College in 1984.

In 1981 he received a fellowship from the New Jersey State Council of the Arts and in 1982 a grant from the National Endowment of the Arts. He is a member of the Harlem Writers Guild, the New Renaissance Writer's Guild, and P.E.N. International. He has written articles for magazines and was an editor for Bobbs-Merrill publishing house. He plays the flute, and photography is a hobby.

Although most of his books are about the black experience or have urban settings, a couple of his books have been based on travels to the East and Africa. His book *Motown and Didi* won the Coretta Scott King Award in 1985 as did *The Young Landlords* in 1980. His *Where Does the Day Go?*, a prize-winning book, was submitted to Parents Magazine Press, in the late 1960s by the Council on Interracial Books for Children.

He is married to Constance Brendel and lives in New Jersey with his three children, Karen, Michael, and Christopher.

Bibliography

Where Does the Day Go? Illustrated by Leo Carty. Parents, 1969.

Fast Sam, Cool Clyde, and Stuff. Viking, 1975.

It Ain't All for Nothin'. Viking, 1978.

The Young Landlords. Viking, 1979.

The Black Pearl and the Ghost. Viking, 1980.

Hoops. Delacorte, 1981.

The Legend of Tarik. Viking, 1981.

Won't Know Till I Get There. Viking, 1981.

Tales of a Dead King. Morrow, 1983.

Motown and Didi: A Love Story. Viking, 1984.

Mr. Monkey and the Gotcha Bird. Delacorte, 1984.

Crystal. Viking, 1987.

Fallen Angels. Scholastic, 1988.

Me, Mop and the Moondance Kid. Illustrated by Rodney Pate. Delacorte, 1988.

The Mouse Rap. Harper, 1989.

Scorpions. Harper, 1989.

Now Is Your Turn! The African-American Struggle for Freedom. HarperCollins, 1991.

Somewhere in the Dark. Scholastic, 1992.

Palmer, C[yril] Everard (1930–)
Author

Writer and teacher C. Everard Palmer was born in Kendal, Jamaica, and educated at Mico Training College in Jamaica and Lakehead University in Thunder Bay, Ontario. He has contributed short stories and articles to Jamaica's leading newspaper. Among his awards is a certificate of merit from the Jamaican Reading Association for his contribution to Jamaican children's literature. He teaches and lives in northwestern Ontario.

Bibliography

The Cloud with the Silver Lining. Bobbs-Merrill, 1966.

Big Doc Bitteroot. Bobbs-Merrill, 1968.

The Sun Salutes You. Bobbs-Merrill, 1970.

Baba and Mr. Big. Bobbs-Merrill, 1972.

A Cow Called Boy. Bobbs-Merrill, 1972.

PATTERSON, LILLIE G.
Author

Patterson has been a teacher as well as chairman of the Elementary Book Reviewing Committee for the Baltimore public school system and a library services specialist. Her book *Martin Luther King, Jr.: Man of Peace* won the Coretta Scott King Award in 1970.

Bibliography

Frederick Douglass: Freedom Fighter. Garrard, 1965.

Martin Luther King, Jr.: Man of Peace. Garrard, 1969.

Sequoyah: The Cherokee Who Captured Words. Garrard, 1975.

Coretta Scott King. Garrard, 1977.

Benjamin Banneker. Abingdon, 1978.

Sure Hands, Strong Heart: The Life of Daniel Hale Williams. Abingdon, 1981.

David, the Story of a King. Abingdon, 1985.

Martin Luther King Jr. and the Freedom Movement. (A Makers of America Book.) Facts on File, 1989.

Oprah Winfrey: Talk Show Host and Actress with Cornelia H. Wright. (Contemporary Women Series) Enslow, 1990.

PETRY, ANN [LANE] (1908–)
Author

 Ann Petry was born in Old Saybrook, Connecticut, and attended Connecticut College of Pharmacy, now known as the University of Connecticut School of Pharmacy. She also attended Columbia University.

 Her writing career started with her work for the *Amsterdam News* in Harlem as a writer and reporter and as women's editor in the 1940s for the *People's Voice*, a New York newspaper. During 1974 and 1975 she was a visiting professor of English at the University of Hawaii. Her awards include a grant from the National Endowment for the Arts. She married George D. Petry and has one daughter.

Bibliography

The Drugstore Cat. Illustrated by Susanne Suba. Crowell, 1949.

Harriet Tubman: Conductor on the Underground Railroad. Crowell, 1955.

Tituba of Salem Village. Crowell, 1964.

Legends of the Saints. Illustrated by Anne Rockwell. Crowell, 1970.

PINKNEY, BRIAN (1961–)
Illustrator

> I'm an artist who likes telling stories through pictures. Picture books allow me to do this. I have a strong connection to experiences I had as a child. Children's books allow me to recreate these experiences for other children.

Brian Pinkney holds both a bachelor of fine arts degree from the Philadelphia College of Art and a master of fine arts degree in Illustration from the School of Visual Arts in New York City. His work has been exhibited at the School of Visual Arts Student Galleries, the Society of Publication Designers Spot Show, and the School of Visual Arts MFA in Illustration as Visual Journalism exhibition. There have also been showings of his work at the Schomburg Center for Research in Black Culture, the National Coalition of 100 Black Women Art Show, and Philadelphia's Afro-American Historical and Cultural Museum.

His illustrations have appeared in the *New York Times Magazine*, the Op-Ed page of the *New York Times*, *Woman's Day*, *Business Tokyo*, *Ebony Man*, and the *Amtrak Express* magazines.

He retains a membership in the Children's Art Carnival and the Graphic Arts Guild.

In February 1990 he was awarded the National Arts Club Award of Distinction for his inclusion in the National Arts Club Exhibition.

Bibliography

The Boy and the Ghost by Robert D. San Souci. Simon & Schuster, 1989.

The Ballad of Belle Dorcas by William H. Hooks. Knopf, 1990.

Harriet Tubman and Black History Month by Polly Carter. Silver, 1990.

A Wave in Her Pocket: Stories From Trinidad by Lynn Joseph. Clarion, 1991.

Where Does the Trail Lead? by Burton Albert. Simon & Schuster, 1991.

Sukey and the Mermaid by Robert D. San Souci. Four Winds, 1992.

PINKNEY, JERRY (1939–)
Illustrator

> When I think about my growing up in a black community, I can easily recall things that impressed me. I remember feeling that there constantly was a lot of color around me. It showed in the way that my family and neighbors dressed, the dances we did, and the music we listened to. Jazz was very important. I try to convey the emotional, flowing quality of jazz in my work. I would like for my work to look like music sounds . . . An illustrator is responsible for expressing himself, but he is also responsible to society for meeting a client's needs. An illustrator's responsibility to society is to depict his subject matter in a way that affects a broad scope of people. As a black artist who has chosen illustration to reach others, I want to depict black folks as naturally and with as much respect as possible.

The artist was born in Philadelphia and educated at the Philadelphia Museum College of Art. An illustrator and designer for many years, Pinkney was involved in design work for the Boston National Center for the Afro-American Artist and a visiting critic for the Rhode Island School of Design.

Pinkney has won several awards for his illustrations, including gold, silver, and bronze medals in the Art Director's Show and awards from the Society of Illustrators and the American Institute of Graphic Arts. He has also received recognition from the Council of Interracial Books for Children, the National Conference of Christians and Jews, the Carter G. Woodson Book Award, and the New England Book Show, among others. His illustrations for *Patchwork Quilt* by Valerie Flournoy won the 1986 Coretta Scott King Award.

His art projects include record album covers and postage stamps for the United States Postal Service Black Heritage Commemorative Series, principally the Harriet Tubman and Martin Luther King, Jr., stamps. In 1982 he was invited to serve on the United States Postal Service Stamp Advisory Committee and in 1985 was invited to serve on the Quality Assurance Sub-Committee.

Pinkney resides with his family in Croton-on-Hudson, New York.

Bibliography

The Adventures of Spider by Joyce Cooper Arkhurst. Little, Brown, 1964.

Song of the Trees by Mildred D. Taylor. Dial, 1975.

Mary McLeod Bethune by Eloise Greenfield. Crowell, 1977.

Childtimes: A Three-Generation Memoir by Eloise Greenfield and Lessie Jones Little. Crowell, 1979.

Count on Your Fingers, African Style by Claudia Zaslavsky. Crowell, 1980.

Patchwork Quilt by Valerie Flournoy. Dial, 1985.

Half a Moon and One Whole Star by Crescent Dragonwagon. Macmillan, 1986.

The Tales of Uncle Remus: The Adventures of Brer Rabbit as told by Julius Lester. Dial, 1987.

The Green Lion of Zion Street by Julia Fields. McElderry Books, 1988.

Mirandy and Brother Wind by Patricia C. McKissack. Knopf, 1988.

More Tales of Uncle Remus: Further Adventures of Brer Rabbit, His Friends, Enemies and Others by Julius Lester. Dial, 1988.

Rabbit Makes a Monkey of Lion by Verna Aardema. Dial, 1989.

The Talking Eggs: A Folktale from the American South by Robert D. San Souci. Dial, 1989.

Turtle in July by Marilyn Singer. Macmillan, 1989.

Home Place by Crescent Dragonwagon. Macmillan, 1990.

Further Tales of Uncle Remus: The Misadventures of Brer Rabbit, Brer Fox, Brer Wolf, the Doodang and All the Other Creatures. Doubleday, 1990.

Falling Pieces of the Broken Sky by Julius Lester. Arcade, 1990.

Pretend You're a Cat by Jean Marzollo. Dial, 1990.

The Man Who Kept His Heart in a Bucket by Sonia Levitin. Dial, 1991.

In for Winter, Out for Spring by Arnold Adoff. Harcourt, 1991.

Sukey and the Mermaid by Robert D. San Souci. Four Winds, 1992.

PRATHER, RAY
Illustrator

The artist grew up in Marianne, Florida. He studied art at Florida Chipola Junior College and continued his studies at Cooper Union in New York City. He has been an art assistant and designer for *Look* magazine, and his illustrations have appeared in *The Nation* and *Black Enterprise*. He lives in Montreal.

Bibliography

Anthony and Sabrina written and illustrated by Ray Prather. 1973.

No Trespassing. Macmillan, 1974.

Double Dog Dare. Macmillan, 1975.

New Neighbors. McGraw, 1975.

The Ostrich Girl. Scribner, 1978.

QUARLES, BENJAMIN (1905–)
Author

Born in Boston, Quarles was educated in local public schools and in 1931 graduated from Shaw University. He is recognized for his knowledge of Afro-American history and scholarly achievements. Quarles earned his Ph.D. in 1940. He was professor of history and dean of instruction at Dillard University and a professor at Morgan State College, where he received fellowships and grants-in-aid from the Social Science Research Council. He also received the President Adams Fellowship in Modern History from the University of Wisconsin and other awards from the Rosenwald and Guggenheim foundations. His affiliation with the Association for the Study of Negro Life and History was productive. He was also president of Associated Publishers and associate editor of the *Journal of Negro History*.

Bibliography

Lift Every Voice with Dorothy Sterling. Zenith, 1965.

RANSOME, JAMES (1961–)
Illustrator

> Each of my books is an attempt to convey a strong sense of family and community to the young reader. With much discussion and media portrayal centered on the large percentage of African-American households headed by single mothers, I have made a conscious effort to present a more well-rounded perspective, which includes the traditional family headed by a mother and father.
>
> On several occasions, I received manuscripts with no mention of a father. I seized the opportunity to insert one, either cooking, cleaning or going to work, but always as a character central to the importance of the story. The communities and background characters I illustrate are of equal importance. Again, I attempt to show the value of the African-American storekeepers, mailpersons, etc., by bringing them to the forefront.
>
> I feel it is these subtle messages we present to our children that are the keys essential to building a healthy self-esteem.

Ransome was born in Rich Square, North Carolina. He earned a bachelor of fine arts in illustration from the Pratt Institute in New York City in 1987.

He has designed book jackets, greeting cards, and tote bags as well as done children's book illustration. His first book illustrations for *Do Like Kyla* by Angela Johnson received the Parenting Magazine's Reading Magic Award. He also received the Jellybean Award in the Society of Illustrators Annual Student Scholarship Competition.

He acknowledges the influence of artists like Cassatt, Sargent, Degas and others on his practice of creating texture on canvas with his brushstrokes, and the oils in his particular palette.

He and his wife Lena live in Jersey City, New Jersey, with their dalmation Clinton, who has been featured in at least one of his books.

Bibliography

Do Like Kyla by Angela Johnson. Richard Jackson Books. Orchard, 1990.

Aunt Flossie's Hats (And Crab Cakes Later) by Elizabeth Howard. Clarion, 1991.

How Many Stars In the Sky? by Lenny Hort. Tambourine, 1991.

Goodbye, Hello by Barbara Shook Hazen. Atheneum/Macmillan, 1992.

REID, DESMOND (1945–)
Author

The third of nine children, Reid remembers seeking solace in books to keep away from the hectic doings in a household with so many children while growing up in Jamaica. From 1961 to 1965 he attended the Gleaner School of Printing in Jamaica, and in 1965 he moved to the United States and was employed in the printing trade with the Theo. Gaus Co. until he joined the U.S. Air Force. It was service in the Air Force that enabled him to complete his secondary schooling. After Theo. Gaus Co. closed, he and three other employees bought the company's printing operation. They later sold it in 1981.

His interest in writing children's books began after he returned for a brief visit to Jamaica, when he wrote his first children's book. Since then, he has occupied himself with the pursuit of advance studies and community work in Brooklyn, New York, where he and his wife reside with their two sons and a daughter.

Bibliography

Dana Meets the Cow Who Lost Its Moo. Gaus, 1984.

RINGGOLD, FAITH (1930–)
Illustrator/Author

[A] painter working in a quilt medium.... I like to feel I'm a writer, but I think I'm a storyteller. All the adults and children in my family told stories but me. I was the youngest. I listened. I write so that people can read me standing up in the gallery. I try to pull them along so they stay with me.
... Black art has a classical basis in African art. The basis of Western art is imitation, and African art is abstraction. Black artists use flattened perspective because it fits black imagery.

A native New Yorker, Ringgold received her master of arts degree from the City College of New York (CUNY) and then worked as an art teacher. She has taught bead work and mask making. She began to paint professionally in the 1970s. After making figurative soft sculptures, she decided in 1980 to make quilts. She had worked earlier with her mother, a fashion designer and dressmaker, who told her stories of slave ancestors making quilts incorporating a painting. Her quilt *Echoes of Harlem* was the first and last project made in collaboration with her mother. Her quilts have a central large painted image framed with a text written on the quilt. Ringgold's work is found in collections of the Museum of Modern Art; the Studio Museum of Harlem; the Metropolitan Museum of Art; and the Solomon R. Guggenheim Museum of New York City; the Fine Arts Museum of Long Island, Hempstead, New York; and the High Museum of Atlanta, Georgia. Her work can also be found in private and corporate collections throughout the United States. A grant from the Lanapoule Foundation enabled her to work on a series of quilts during a four-month residence during 1990–1991, in France.

Her quilt *Tar Beach*, completed in 1988, is from her "Woman on a Bridge" series, now part of the Solomon R. Guggenheim collection. It served as the basis of Ringgold's first picture book, *Tar Beach*, which recreates scenes of Harlem from a rooftop overlooking the George Washington Bridge in New York City.

In 1989 Ringgold received a National Endowment for the Arts Award for Painting.

She is a professor of art at the University of California at San Diego and is a resident of both New York City and La Jolla, California. She and her husband, Burdette Ringgold, are the parents of two daughters.

Bibliography

Tar Beach. Crown, 1991.

ROBINET, HARRIETTE GILLEM (1931–)
Author

Robinet grew up in Washington, D.C., and recalls childhood summer vacations near the Robert E. Lee mansion in Arlington, Virginia, where her grandparents had lived as slave children. She received her bachelor's degree at the College of New Rochelle and graduate degrees at the Catholic University of America. She worked as a research bacteriologist at Walter Reed Army Medical Center and taught biology at Xavier University.

Her writing began after her family's move to Illinois in 1960. *Ride the Red Circle* is based on personal observations of her son, disabled by cerebral palsy, and many other disabled youngsters she has met. She lives with her husband and six children in Oak Park, Illinois.

Bibliography

Ride the Red Circle. Houghton, Mifflin, 1980.

Children of the Fire. Atheneum, 1991.

ROBINSON, ADJAI (1932–)
Author

This native of Sierre Leone, Africa, studied at Columbia University. He began collecting folktales from Nigeria and his native country for storytelling on radio in Sierra Leone. His folktale collection and storytelling skills have helped him with his studies at Hunter College in New York City and the United States International School.

Bibliography

Femi and Old Grandaddie. Illustrated by Jerry Pinkney. Coward, 1972.

Kasho and the Twin Flutes. Illustrated by Jerry Pinkney. Coward, 1973.

Singing Tales of Africa. Illustrated by Christine Price. Scribner, 1974.

Three African Tales. Illustrated by Carole Byard. Putnam, 1979.

ROBINSON, DOROTHY WASHINGTON (1929-)
Author

> Every child brings into the world a very special and unique gift. Every adult must work to see to it that the children's gifts are nurtured, protected, and developed toward the creation of a peaceable community.

Robinson was born in Waycross, Georgia, and is the divorced mother of two children. She earned a bachelor of arts degree from Fisk University and a master's degree in library science from Atlanta University.

She is a member of the American Library Association and the Association for the Study of Negro Life and History. In 1975 she received the Coretta Scott King Award for her book, *Legend of Africania*.

Bibliography

Legend of Africania. Illustrated by Herbert Temple. Johnson, 1974.

Martin Luther King and the Civil Rights Movement. Jehara, 1986.

ROBINSON, LOUIE, JR. (1926–)
Author

Louie Robinson was born in Dallas and attended Lincoln University in Jefferson City, Missouri. He served in the army during World War II. He has contributed to *Jet*, *Ebony*, *Tan*, and *Negro Digest* magazines. He was also an editor for *Jet* and *Romance* magazines and served as *Ebony*'s West Coast Bureau Chief.

Bibliography

Arthur Ashe, Tennis Champion. Doubleday, 1967.

ROLLINS, CHARLEMAE [HILL] (1897–1979)
Author

Rollins was born in Yazoo City, Mississippi, and attended Western University, the University of Chicago, and Columbia University, from which she received an honorary doctorate in 1974. She moved to Chicago in 1927. Her attempts to collect materials on blacks revealed that little positive information was available for children. She began collecting material to combat existing stereotypes and was, as a result, instrumental in editing the bibliography *We Build Together*. It was published by the National Council of the Teachers of English in 1963 and revised in 1967. The bibliography defined criteria for selecting literature depicting minorities in a positive light.

Rollins was a well-known librarian, children's literature specialist, author, and lecturer. In 1979 she was voted Young Reader's Choice by children in Alaska, Idaho, Montana, Oregon, Washington, British Columbia, and Alberta in a contest sponsored by the Children's and Young Adult divisions of the Pacific Northwest Library Association. She received the American Library Association Library Letter Award in 1953, the Grolier Society Award in 1955, the Constance Lindsay Skinner Award of the WNBA in 1970, and the Coretta Scott King Award in 1971. She was also made an honorary member of Phi Delta Kappa.

After working for thirty-six years in the Chicago Public Library, Rollins retired in 1963 as head of the children's room at the George C. Hall Branch. She served as president of the American Library Association's Children's Services Division in 1957–1958 and was a member of the Newbery-Caldecott Committee.

Rollins attributed her love for books to her grandmother, a former slave. A room of the Carter G. Woodson Regional Library in Chicago was dedicated to her in 1977.

Bibliography

Christmas Gif'. Follett, 1963.

They Showed the Way: Forty American Negro Leaders. Crowell, 1964.

Famous Negro Poets. Dodd, 1965.

Famous Negro Entertainers of Stage, Screen and TV. Dodd, 1967.

Black Troubador, Langston Hughes. Rand McNally, 1970.

RUFFINS, REYNOLD (1930–)
Author/Illustrator

The artist has been a designer and illustrator for commercial ads and magazines, *Family Circle* among them. He has taught at the School of Visual Arts in New York City and Syracuse University's College of Visual and Performing Arts. He has received awards from the Art Directors Club and the American Institute of Graphic Arts, as well as the Cooper Union Professional Achievement Award. He has also received prizes from the Bologna Children's Book Fair in 1976, *California* magazine, the Society of Illustrators, and the New York Historical Society. He began illustrating books after meeting author Jane Sarnoff at a civil rights protest march in 1973.

Ruffins was born in New York City and grew up in Queens. He remembers drawing at a very early age. He attended the High School of Music and Art in Manhattan, and later, Cooper Union in New York City. While at Cooper Union, he, Milton Glaser, Seymour Chwast, John Alcorn, Paul Davis, and some others formed the Push Pin Studios on 13th Street in New York City, sharing the loft space with a dancer. He teaches at the Parsons School of Design in New York.

Bibliography

My Brother Never Feeds the Cat. Scribner, 1979.

If You Were Really Superstitious by Jane Sarnoff. Scribner, 1980.

That's Not Fair by Jane Sarnoff. Scribner, 1980.

Words: A Book About the Origins of Everyday Words and Phrases by Jane Sarnoff. Scribner, 1981.

SALKEY, [FELIX] ANDREW (1928–)
Author

Salkey was born in Colon, Panama, and grew up in Jamaica. He attended St. George's College in Kingston and Munro College in St. Elizabeth and earned his bachelor's degree in English from the University of London. He received the Thomas Helmore Poetry Prize in 1955 and a Guggenheim Fellowship in 1960. Salkey taught English in a London comprehensive school and in 1952 became a radio interviewer and scriptwriter for BBC External Services. He married Patricia Verden in 1957, and they have two sons. He lived in London from the early 1950s until 1976. Currently, he is a professor at Hampshire College in Massachusetts.

Bibliography

Hurricane. Oxford, 1964.

Earthquake. Oxford, 1965.

Jonah Simpson. Oxford, 1969.

Serwadda, William Moses (1931-)
Author

William Serwadda, son of a Mukanja farmer from the shores of Lake Victoria, in central Africa, was on the faculty of the Department of Music and Dance at Makarerell in Kampala, Uganda. His popular biweekly TV program of traditional African music for children received the highest rating. Highly regarded by the Ministry of Culture for his personal musical style, Serwadda was considered a model for his performance of traditional music. Since Uganda's fight for independence in 1962 he has traveled around the country training local clubs interested in preserving traditional music.

Serwadda has a master's degree in African studies from the University of Ghana. He has directed choirs in many festivals celebrating African music in his own country as well as Canada, the United States, and Europe. The songs and stories from his book, *Songs and Stories from Uganda*, come from his personal collection of folk material, much of which was acquired in childhood when he lived with his grandfather, an administrator appointed by the king of the Baganda.

Bibliography

Songs and Stories from Uganda. Transcribed and edited by Hewitt Pantaleoni. Illustrated by Leo and Diane Dillon. Crowell, 1974.

SHEARER, JOHN (1947–)
Author

Winner of over twenty national awards, this author/photographer was born in New York and attended the Rochester Institute of Technology and the School of Visual Arts in New York City. His photography has been exhibited in IBM galleries in New York, in the Metropolitan Museum of Art's exhibition "Harlem on My Mind," and at Eastman Kodak galleries. Shearer was a staff photographer for *Look* in 1970 and *Life* from 1971 to 1973 and taught journalism at Columbia University in 1975. He was president of Shearer Visuals in White Plains, New York, from 1980 to 1984. He produces films featuring characters Billy Jo Jive and Susie Sunset for "Sesame Street."

His *Super Private Eye: The Case of the Missing Ten Speed Bike* won a communications award in 1978. Shearer also received the Ceba Award in 1978 for his animated film, *Billy Jo Jive*. His Billy Jo Jive books, a mystery series for younger readers, are illustrated by his father, cartoonist Ted Shearer.

Bibliography

I Wish I Had an Afro. With the author's illustrations and photographs. Cowles, 1970.

Little Man in the Family. With the author's illustrations and photographs. Delacorte, 1972.

Billy Jo Jive and the Case of the Midnight Voices. Illustrated by Ted Shearer. Delacorte, 1982.

Sherlock, Sir Philip [Manderson] (1902–)
Author

Born in Jamaica and educated at the University of London as an external student, Sherlock earned his bachelor's degree with first-class honors. He has since received an honorary L.L.D. from the University of Leeds and St. Andrews, and honorary doctorates from the University of New Brunswick and Acadia University. He was vice-chancellor of the West Indies and was named Knight Commander of the British Empire in 1968. His memberships have included the Association of Caribbean Universities and Research Institutes, the Authors Guild, National Liberal Club, and the West India Club. His principal award was "Commander of the British Empire."

Bibliography

Anansi, the Spider Man. Crowell, 1954.

West Indian Folk Tales. Oxford, 1966.

Iguana's Tail: Crick Crack Stories from the Caribbean. Crowell, 1969.

Ears and Tails and Common Sense: More Stories from the Caribbean with daughter Hilary Sherlock. Crowell, 1974.

STEPTOE, JOHN [LEWIS] (1950–1989)
Author/Illustrator

Born in Brooklyn, the artist attended the New York School of Art and Design, worked with HARYOUACT (a Harlem community program designed to encourage artistic and creative endeavors among young urban African Americans), and studied with painter Norman Lewis. Recognition of his talents began with his first published book, *Stevie*, written and illustrated when he was sixteen and seventeen years old. Among his awards are the Society of Illustrators Gold Medal in 1970, the Coretta Scott King Award in 1981, the Irma Simonton Black Award from the Bank Street College of Education in New York City in 1975, and the 1985 Caldecott Honor Book Award for *The Story of Jumping Mouse: A Native American Legend*.

Bibliography

Stevie. Harper, 1969.

Uptown. Harper, 1970.

Train Ride. Harper, 1971.

All Us Come Cross the Water by Lucille Clifton. Holt, 1973.

My Special Best Words. Viking, 1974.

She Come Bringing Me That Little Baby Girl by Eloise Greenfield. Lippincott, 1974.

Marcia. Viking, 1976.

Daddy Is a Monster . . . Sometimes. Lothrop, 1980.

Mother Crocodile = Maiman-Caiman by Birago Diop. Translated by Rosa Guy. Lothrop, 1981.

Outside-Inside Poems by Arnold Adoff. Lothrop, 1981.

All the Colors of the Race by Arnold Adoff. Lothrop, 1982.

Jeffrey Bear Cleans Up His Act. Lothrop, 1983.

The Story of Jumping Mouse: A Native American Legend. Lothrop, 1984.

Mufaro's Beautiful Daughters. Lothrop, 1987.

Baby Says. Lothrop, 1988.

Birthday. Reissue. Holt, 1991.

STEWART, RUTH ANN (1942–)
Author

> In writing *Portia*, it was my intention to tell the story, in an interesting and lively manner, of a talented, courageous woman whose life also provided a previously unknown perspective on an important chapter in African American history. I wanted the results to be enjoyable to both young adult and adult readers and to stimulate their interest in delving further into black history, especially black women's history. It is my belief that far too little has been written about the black middle-class woman and the important role she has played as both a mainstay of black family life and an accomplished member of a variety of professions.
>
> Even though Portia was the daughter of a famous man, her career aspirations, and personal struggles are common to the stories yet to be written of many black women. Through further scholarship into the rich mine of human lore posed by African American life, and with the encouragement of an alert and interested reading public, it is my hope that this literary shortcoming will be vigorously addressed and there will be many Portias (including a few more of mine) taking their place on the shelves of libraries and bookstores in the near future.

Stewart was born in Chicago, where she attended the University of Chicago in 1961–1962 and completed her undergraduate studies at Wheaton College in Massachusetts with a bachelor of arts in 1963. She then earned a master of science degree from Columbia University and in 1974 took courses at Harvard University, as well as at the Kennedy School of Government in 1987. Her book, *Portia . . .*, was cited as a Coretta Scott King Honor Book in 1977.

She was awarded an International Council of Museums Fellowship. Her memberships include Library Visiting committees at Harvard University and M.I.T., the Board of Visitors at the Pittsburgh School of Library and Information Science, the Board of Trustees at Wheaton College and the Council on Foreign Relations, and the District of Columbia Historical Records Advisory Board.

She lives in Washington, D.C., with her daughter.

Bibliography

Portia: The Life of Portia Washington Pittman, the Daughter of Booker T. Washington. Doubleday, 1977.

SUTHERLAND, EFUA [THEODORA MORGUE] (1924–)
Author

> What we cannot buy is the spirit of originality and endeavor which makes a people dynamic and creative.

Efua Sutherland, a native of Ghana, is a founder of the Ghana Society of Writers, the Ghana Drama Studio, Ghana Experimental Theatre, and a community project called the Kodzidan (the "story house"). She studied at St. Monica's College, Cambridge, England, and the School of Oriental and African Studies at the University of London. She was a research fellow in literature and drama at the Institute of African Studies, University of Ghana and is a co-founder of *Okyeame* magazine. Sutherland taught school from 1951 to 1954 and in 1954 married Afro-American William Sutherland. They have three children and live in Ghana. Sutherland publishes widely in her native land and her work has been included in short story anthologies in the United States.

Bibliography

Playtime in Africa. Photographs by Willis E. Bell. Atheneum, 1962.

TADJO, VERONIQUE (1955–)
Author/Illustrator

> I write children's books because it is important for children
> to get plenty of the right reading material, which is going to
> help them shape their personality. Black children in this
> respect are not sufficiently provided for. It is my belief that
> black writers should write more books of quality for the
> young readership. There is a need for positive images of
> black people from the past and present. I am also interest-
> ed in promoting African culture and introducing it to
> children with different experiences. It is a way of preparing
> them for a more sophisticated view of the world.

The author was born in Paris, France, and now lives
in Ivory Coast, a country in West Africa. She is married
to Nick Kotch, and they are parents of one son, Larry
Tadjo Kotch.

Tadjo has a "licence" from the University of
Abidjan, 1980, a master's degree, 1981, and a doctor-
ate, 1983, from the Sorbonne in Paris. Her father is an
auditor general in the Ivory Coast and her mother, a
painter and sculptor.

Her work appeared at the Twenty-Fourth Exhibi-
tion of Original Pictures of Children's Books in Japan,
the summer of 1983. She is a member of the Croix
Verte de Côte d'Ivoire (Ecological Movement of the
Ivory Coast).

Tadjo became enamored with the culture of the
people in the northern part of the Ivory Coast after
teaching there for three years. These people of the
north, the Senufo, are farmers. They believe that spirits
inhabit nature. As weavers, they decorate their cloth
with pictures of the hidden spirits in which they be-
lieve. They also make ceremonial carved wood masks
to be used for special celebrations, harvest feasts, or
funerals. The mask wearing is assigned to one person
only. Upon his death another person is specifically
assigned to be the mask wearer.

Tadjo first heard the hymn "Lord of the Dance" at
a wedding in England. It reminded her of the Senufo

mask making and inspired her to write her book of the same title. She uses the Senufo art motif in her illustrations for the book, substituting bright colors for the earth tones that the Senufo might use.

Bibliography

The Lord of the Dance: An African Retelling. Lippincott, 1989.

TARRY, ELLEN (1906–)
Author

The author was born in Birmingham, Alabama. After her arrival in New York, she joined the Writers Workshop at Bank Street College. Writers Workshop was the brainchild of Lucy Sprague Mitchell, the progressive educator and founder of Bank Street College. Tarry's book *My Dog Rinty*, which grew out of a collaboration with Marie Hall Ets, was popular because of its portrayal of Harlem in the 1940s. She worked as an Intergroup Relations Specialist with the Department of Housing and Urban Development. Tarry lives in New York.

Bibliography

My Dog Rinty with Marie Hall Ets. Viking, 1946.

Young Jim: The Early Years of James Weldon Johnson. Dodd, 1967.

TATE, ELEANORA ELAINE (1948–)
Author

Tate was born in Canton, Missouri, and raised by her grandmother, Corinne E. Johnson. She graduated from Roosevelt High School in Des Moines, Iowa, and received a bachelor's degree in journalism with a specialty in news editorial from Drake University in 1973.

Her first poem was published when she was sixteen. She started her career as a news reporter and news editor in Des Moines and Jackson, Tennessee. In 1981 Tate received a fellowship in children's literature from the Bread Loaf Writers Conference in Middlebury, Vermont, and in 1982 completed five weeks' travel and research in selected ethnic folk and fairy tales in West Germany and France and in Florence and Collodi, Italy. In 1981 and 1982 Tate was a guest author at the South Carolina School Librarians Association, workshop leader at the 1982 Young Authors Conference, guest speaker at the South Carolina Federation of Business and Professional Women's Clubs' Sixty-Second Annual Convention, and guest speaker at the South Carolina Library Association's annual convention.

Tate has been on the board of governors of the South Carolina Academy of Authors and a member of its board of directors.

Her memberships include the Iowa Arts Council Writers in School program, the South Carolina Arts Commission's artists' roster, the Horty Cultural Arts Council, the Pee Dee Reading Council in Myrtle Beach, and a board membership of the National Association of Black Storytellers.

She received the Presidential Award from the South Carolina chapter of the National Association of Negro Business and Professional Women's Clubs in 1988. She is listed in the Southern Arts Federation's Regional Black Arts Directory. Her book *Just an Overnight Guest* became the basis for a film of the same name produced by Phoenix Films, Inc., New York.

Tate is co-owner and president of Positive Images, Inc., in Myrtle Beach, South Carolina, and is married to Zack E. Hamlett III. They have one daughter, Gretchen.

Bibliography

Just an Overnight Guest. Dial, 1980.

The Secret of Gumbo Grove. Watts, 1987.

Thank you, Dr. Martin Luther King, Jr. Watts, 1990.

TAYLOR, MILDRED D. (1943–)
Author

Taylor was born in Jackson, Mississippi, but spent her childhood in Toledo, Ohio, where she attended secondary school and college. After her graduation from the University of Toledo, Taylor joined the Peace Corps in Ethiopia teaching English and history. She became a Peace Corps recruiter upon her return to the United States.

Taylor received a master's degree from the University of Colorado's School of Journalism. As a member of their black student alumni group, she helped organize a black studies program and worked as a study skills coordinator.

Her first book, *Song of the Trees*, won the Council on Interracial Books for Children competition, was voted an outstanding book of 1975 by the *New York Times*, and in 1976 was named a Children's Book Showcase book. *Roll of Thunder, Hear My Cry* won the Newbery medal in 1977 and a nomination for the National Book award; it was voted a Boston Globe-Horn Book Award Honor Book and a Notable Children's Trade Book in the field of social studies by the Children's Book Council and the National Council for Social Studies joint committee.

Taylor's Logan family trilogy ended with *Let the Circle Be Unbroken* in 1981. This title was a 1982 American Book Award nominee and a Coretta Scott King Award winner. It was listed among the American Library Association's Best Books for Young Adults in 1981. Taylor resides in Colorado.

Bibliography

Song of the Trees. Dial, 1975.

Roll of Thunder, Hear My Cry. Dial, 1976.

Let the Circle Be Unbroken. Dial, 1981.

The Gold Cadillac. Dial, 1987.

The Friendship. Illustrated by Max Ginsburg. Dial, 1987.

The Road to Memphis. Dial, 1989.

Mississippi Bridge. Illustrated by Max Ginsburg. Dial, 1990.

THOMAS, DAWN C.
Author

Thomas is a teacher who was actively involved in the social issues of her New Jersey community. Some of her childhood experiences in Barbados, Harlem, and Brooklyn can be found in her books. She is currently living in Barbados.

Bibliography

A Bicycle from Bridgetown. Illustrated by Don Miller. McGraw-Hill, 1975.

THOMAS, IANTHE (1951–)
Author

Thomas was a nursery school teacher, worked in children's theater, and developed educational curriculum. She studied sculpture at the Universidad de Coimbra in Portugal and has exhibited her wrought iron and milled steel pieces in one-woman shows. Her books are noted for their use of black speech patterns and focus on personal relationships.

Bibliography

Lordy Aunt Hattie. Illustrated by Thomas Di Grazia. Harper, 1973.

Eliza's Daddy. Illustrated by Moneta Barnett. Harcourt, 1976.

My Street's a Morning Cool Street. Illustrated by Emily A. McCully. Harper, 1976.

Hi, Mrs. Mallory! Illustrated by Toulmin-Rothe. Harper, 1979.

Willie Blows a Mean Horn. Illustrated by Toulmin-Rothe. Harper, 1981.

THOMAS, JOYCE CAROL (1938–)
Author

For many years Thomas has been known in the San Francisco Bay area for her poetry. The acclaim given her novel *Marked by Fire*, a 1983 American Book Award winner in the paperback category for children's fiction, brought her to the forefront as a novelist.

She was born in Ponca City, Oklahoma, one of nine children. She recalls picking cotton as a child. As an adult she worked as a telephone operator by day while attending night classes and was, at the same time, responsible for raising four children. She earned her bachelor's degree in Spanish at San Jose University and her master's in education from Stanford University. Among her awards are the Djerassi Fellowship for Creative Artists at Stanford, the Before Columbus American Book Award for her prize-winning novel, *Marked by Fire*, and the Danforth Graduate Fellowship at the University of California at Berkeley. *Marked by Fire* was named a best book by the Young Adult Services Division of the American Library Association and cited as one of the outstanding books of the year, 1982, by the *New York Times*.

Editor of a black women's newsletter, *Ambrosia*, accomplished playwright, poet, and author, Thomas has lectured in Africa, Haiti, and the United States. She has also served as an assistant professor of black studies at California State University and visiting professor at Purdue University.

Bibliography

Marked by Fire. Avon, 1982.

Bright Shadow. Avon, 1983.

Journey. Scholastic, 1989.

A Gathering of Flowers: Stories About Being Young in America. Harper, 1990.

TURNER, GLENNETTE TILLEY (1933–)
Author

Children have only one short, perishable moment in which to discover themselves, their worth, their history, and their potential. As a classroom teacher of more than twenty-four years, my goal was to help make that discovery joyous and so inspiring it would sustain children through the challenges of life.

I grew up loving to learn. I enjoyed reading, finding out the meaning of words and ideas, and listening to stories. From the time I was little, I was especially intrigued by family stories and the stories of people who overcame the odds. During my formative years I found that I could express myself best by writing. My parents and teachers encouraged me to explore different kinds of writing.

After I became an adult I realized that I had not outgrown my enjoyment of the types of stories that had intrigued me as a child—and that the children in my life were just as interested in such stories as I was. I began to write for my children, my students, and for readers of children's magazines and books. I found teaching very satisfying; however, it left little time for writing. For me retirement was not actually retirement from teaching. It meant stepping from a school classroom into a classroom without walls. It enabled me to devote more time to writing and provided greater opportunity to accomplish a long-held goal: to help children experience the joy and inspiration that comes from discovering themselves, their worth, their history, and their potential.

Glennette Turner was born in Raleigh, North Carolina. She and her husband, Albert Turner, are the parents of two sons. She received her bachelor of arts from Lake Forest College in Illinois and her master of arts from Goddard College in Vermont. Since then she has taken fifty additional hours of graduate studies.

Currently, the author not only writes but is a student-teacher supervisor for National Louis University in Evanston, Illinois. Her life is busy with civic and educational pursuits and associations. Among her memberships are the Children's Reading Round Table of Chicago, where she served as president and now

chairs the Special Projects Committee. She is a found-ing member and past president of the Black Literacy Umbrella. She is also a member of the Association of Black Women Historians, the Association for the Study of Afro-American Life and History, the Afro-American Genealogical and Historical Society of Chicago and Washington, D.C., the Chicago chapter of the Patricia Liddell Researchers, the NAACP, the League of Women Voters, and Operation PUSH. She is also a commis-sioner of the City of Wheaton (Illinois) Cable Com-mission, and a member of the Northern Illinois Uni-versity Children's Literature Conference Committee, and a consultant to Naper Historical Settlement (Naperville, Illinois).

Her election to the Lake Forest chapter of Phi Beta Kappa was for scholarly achievement since graduation from college. She has been awarded a distinguished Alumni Award from West Aurora High School, Illinois, and named Outstanding Woman Educator in Du Page County, Illinois.

Her story "Gram Remembers" appeared in an early edition of Open Court Readers and has recently been reissued; and "The Passenger," a story featured earlier in *Scholastic Scope*, has been selected for a new Scho-lastic anthology.

As a child, Turner used to accompany her father on fund-raising trips to small neighborhood churches where he asked for support for the small colleges he had served as president at one time or another, in-cluding Shaw University and Florida Normal. His speeches were generally about some bit of family his-tory or stories, and she feels that these influenced her view or interest in the historical background of her people. Even her own eventual settling in Illinois may have been influenced by her mother's constant longing and nostalgia for her birthplace, Illinois. The young Glennette saw Illinois in her mind's eye as some type of Paradise.

Bibliography

The Underground Railroad in Du Page County, Illinois. Newman, 1988.

Take a Walk in Their Footsteps. Newman, 1988.

Take a Walk in Their Shoes. Cobblehill/Dutton, 1989.

Make and Keep Family Memories with Phyllis Tilley. Newman, 1990.

Lewis Howard Latimer. Pioneers in Change series. Silver Burdett, 1991.

Walker, Alice (1944–)
Author

Alice Walker was born in Eatonton, Georgia. She attended Spelman College in Georgia and graduated in 1966 from Sarah Lawrence College in Bronxville, New York. She married Melvyn Rosenman Leventhal and has one daughter, Rebecca Grant.

Walker was a social service case worker for the New York City Welfare Department, a teacher of black studies at Jackson State University, Mississippi, from 1968 to 1969, and writer-in-residence at Tougaloo College, Mississippi, from 1969 to 1970. She also designed a course on black women writers, first taught at Wellesley College and later at the University of Massachusetts.

Among her awards are the Charles Merrill Writing Fellowship (1967–1968), the National Foundation for the Arts Award in fiction (1969–1970), the Rosenthal Award of the National Institute of Arts and Letters (1973). In 1983 she won he American Book Awards and the Pulitzer Prize for *The Color Purple*, a novel for adults. She won the O. Henry Award (1986) for her short story "Kindred Spirits."

Walker has been a contributing editor to *Southern Voices*, *Freedom Ways*, and *MS* magazine.

She is co-founder and publisher (1984) of Wild Trees Press in Navarro, California. She lives in San Francisco.

Bibliography

Langston Hughes, American Poet. Illustrated by Don Miller. Crowell, 1974.

To Hell with Dying. Illustrated by Catherine Deeter. Harcourt, 1988.

Finding the Green Stone. Illustrated by Catherine Deeter. Harcourt, 1991.

WALTER, MILDRED [PITTS] (1922–)
Author

> I came to books late, and later still, to the knowledge that anyone who loves words and applies discipline to that love can create books.
>
> Being denied access to public libraries and books sharpened my desire to know, not only *what* but also *why*. My first opportunity to become a published writer came because I wanted to know why there were so few books for and about the children I taught who were black.
> "Write some," I was told. Write I did out of a need to share with all children the experiences of a people who have a rich and unique way of living that has grown out of the ability to cope and to triumph over racial discrimination.
>
> My greatest joy is when I see a black child light up when finally there is comprehension that I am the writer, a part of the creation of a book. My having done it, seems to say to him/her, "She did it, I can, too."

Mildred Pitts Walter was born in De Ridder, Louisiana. She is the widow of Earl Lloyd Walter, and the mother of two sons, Earl L., Jr., and Craig A. Walter. She received her bachelor's degree in English from Southern University. Further studies took her to California and the Antioch Extension in Denver, where she received her master's degree in education. She has been a teacher in Los Angeles Unified School District, a consultant at Western Interstate Commission of Higher Education in Boulder, Colorado, and a consultant, teacher, and lecturer in Metro State College. Since 1969 she has devoted most of her time to writing.

Walter has traveled to many parts of the United States and to China and Africa, where in 1977 she was a delegate of the African and Black Festival of the Arts in Lagos, Nigeria. With her husband, who was city chairman of the Congress of Racial Equality, she also worked with the American Civil Liberties Union and the NAACP for desegregation in Los Angeles schools. Out of these experiences and her interviews with people during the Little Rock civil rights crisis grew the ideas for one of her books, *The Girl on the Outside*. Walter now lives in Denver.

Bibliography

Ty's One Man Band. Illustrated by Margot Tomes. Four Winds, 1980.

The Girl on the Outside. Lothrop, 1982.

Because We Are. Lothrop, 1983.

My Mama Needs Me. Illustrated by Pat Cummings. Lothrop, 1983.

Brother to the Wind. Illustrated by Leo and Diane Dillon. Lothrop, 1985.

Trouble's Child. Lothrop, 1985.

Justin and the Best Biscuits in the World. Lothrop, 1986.

Mariah Loves Rock. Bradbury, 1988.

Have a Happy. . . . Illustrated by Carole Byard. Lothrop, Lee & Shepard, 1989.

Mariah Keeps Cool. Bradbury, 1990.

Two and Too Much. Illustrated by Pat Cummings. Bradbury, 1990.

WALTON, DARWIN MCBETH (1926–)
Author

> My writing is based on my belief that children must be aided in establishing confidence in themselves and what they can become, provided they understand the laws of the consequences of their behavior. Too many children think they can't; consequently, they don't try to succeed in school. I want to help change that kind of thinking, to help them realize that nothing worth having comes or stays without effort—love or clean air—that we are what we think, say and do.

Darwin Walton was born in Charlotte, North Carolina, just before the Great Depression. Having learned to defend herself in school at an early age, Walton generally writes about reconciliation and tolerance, demonstrating that being different is not bad. Her book *What Color Are You?* was first published in 1973 at a time when few books contained pictures or stories about minority children.

Walton has a bachelor of science degree from the Chicago Conservatory College of Music and a master's degree from National Louis University, in Evanston, Illinois. She has taught both in elementary and junior high schools in Chicago and Elmhurst, Illinois, and is currently on the adjunct faculty of National Louis University Graduate School of Education.

She is the founding member of Phi Delta Kappa, National College Chapter; a life member of Sigma Alpha Iota International Music Fraternity; president, Black Literacy Umbrella; board member, Children's Reading Round Table; immediate past president, Du Page City NAACP Women's Auxiliary; and clerk on the executive board, York Center Church of Brethren.

Bibliography

What Color Are You? Revised Edition. Johnson, 1985.

Bookworms Are Made, Not Born. Jadar Jr., 1987.

The Mayor Who Conquered Chicago. Path, 1990.

WARD, JOHN C. (1963–)
Illustrator

The artist was born in Brooklyn, New York, and received his bachelor of fine arts degree from the School of Visual Arts in New York City.

A member of the New York chapter of the Graphic Artists Guild, Ward has received the Rhodes Family Award for Outstanding Achievement in media arts from the School of Visual Arts. His work has been exhibited at the Society of Illustrators in New York and appeared in *Communication Arts Illustration Annual*, 1987, *Print Magazine's Regional Design Annual*, 1989, and the *Society of Illustrators 32nd Annual*.

Bibliography

We Keep a Store by Anne Shelby. Orchard, 1990.

The Adventures of High John the Conqueror by Steve Sanfield. Orchard, 1990.

WHITE, EDGAR B. (1947–)
Author

Born in the British West Indies, Edgar White came to the United States when he was five years old. He received his bachelor's degree at New York University and completed graduate study at Yale University. His *Underground: Four Plays* and *Crucificardo: Plays* were published by William Morrow and performed at several theaters, including the New York Shakespeare Festival Public Theatre and the Eugene O'Neill Foundation. He has written for magazines and the *Yardbird Reader #1*.

Bibliography

Omar at Christmas. Illustrated by Dindga McCannon. Lothrop, 1973.

Sati the Rastifarian. Illustrated by Dindga McCannon. Lothrop, 1973.

Children of Night. Illustrated by Dindga McCannon. Lothrop, 1974.

WILKINSON, BRENDA (1946–)
Author

Brenda Wilkinson was born in Moultrie and grew up in Waycross, Georgia, the daughter of Malcolm and Ethel (Anderson) Scott and the second of their eight children. She attended Hunter College of the City University of New York and is a member of the Authors Guild, the Authors League of America, P.E.N. International, and the Harlem Writers Guild. *Ludell*, her first book, was a National Book Award nominee in 1976. It was also noted as "Best of the Best" in *School Library Journal*'s listing for 1976–1978. In December 1977 *Ludell and Willie* was voted an outstanding children's book of the year by the *New York Times* and also in 1977 listed among the best books for young adults by the American Library Association.

Wilkinson is a novelist, short story writer, and poet. Her short story "Rosa Lee Loves Bennie" was included in Sonia Sanchez's anthology, *We Be Word Sorcerers*. She lives in New York with her two children, Kim and Lori.

Bibliography

Ludell. Harper, 1975.

Ludell and Willie. Harper, 1977.

Ludell's New York Time. Harper, 1979.

Not Separate, Not Equal. Harper, 1987.

Jesse Jackson: Still Fighting the Dream. Illustrated by Glenn Wolff. Silver Burdett, 1991.

WILSON, BETH [PIERRE]
Author

Wilson was born in Tacoma, Washington, and graduated from University of Puget Sound, continuing her studies at the University of California in Los Angeles. She was an elementary school teacher in California, a human relations educational consultant, and a consultant in creative writing for children and for African-American studies in the Berkeley public school system. Wilson has written poems, music, and greeting cards as well as children's books. She has traveled to Africa, Mexico, Canada, Scandinavia, and Hawaii. She is married to a dentist and lives in California.

Bibliography

Martin Luther King, Jr. Putnam, 1971.

Great Minu. Follett, 1974.

Muhammad Ali. Putnam, 1974.

Giants for Justice. Harcourt, 1978.

Stevie Wonder. Putnam, 1979.

Jenny. Illustrated by Dolores Johnson. Macmillan, 1990.

WILSON, JOHNNIECE MARSHALL (1944–)
Author

Wilson states that her purpose in writing is to always touch the reader in some way. Fiction is very real. As a writer—an author—I am the first person to read my books, and I have to touch my own emotions first in order to touch and strike an emotion in other readers. If this isn't or can't be done, don't bother writing. Make the readers laugh or cry and get them mad, or make them say, "Ah, this is how it is."

The author was born in Montgomery, Alabama. She works at a medical center in Pittsburgh and is a graduate of that city's Polytechnic Senior High School.

Her first novel, *Oh, Brother*, was an International Reading Association Choice for 1989. Wilson is a member of the National Writers Club and the Authors Guild.

She lives in Wilkinsburg, Pennsylvania. She has three daughters.

Bibliography

Oh, Brother. Scholastic, 1988.

Robin on His Own. Scholastic, 1990.

WOODSON, CARTER GOODWIN (1875–1950)
Author

Woodson was born in Canton, Virginia, in 1875. He completed high school when he was twenty-two years old and went on to study at Berea College and the University of Chicago, where he earned both bachelor's and master's degrees. He earned his Ph.D. at Harvard University in 1912 and then enrolled at the Sorbonne in Paris. He taught elementary and high school and was a dean of the College of Liberal Arts at Howard University and West Virginia State College.

In 1915 Woodson, described as "the father of modern Negro historiography," organized the Association for the Study of Negro Life and History so that culture and history would be recognized. The *Journal of Negro History* was started when the association was established. The *Negro History Bulletin*, started in 1930, aimed to give school children historical information about their heritage. Woodson's interest in Afro-American history led him to collect documents, write, and compile data on Afro-American roots and heritage.

Bibliography

African Heros and Heroines. Associated Publishers, 1938, 1944.

African Myths. Revised Edition. Associated Publishers, 1948.

Negro Makers of History. Revised Edition. Associated Publishers, 1948.

Story of the Negro Retold. Revised Edition. Associated Publishers, 1959.

WOODSON, JACQUELINE (1964–)
Author

> I have chosen to write for young adults with an emphasis on children-of-color to enlighten them to the different issues we as people of color continually struggle with. Issues such as nurturing the gifted black child, racism, classism, and homophobia play major roles in my writing. These are issues that were absent in the literature I read growing up; issues I want my own children to grow up enlightened to. When I go into a classroom to speak about my writing, my objective is to show the children there that there really isn't a "generation gap" between writers and readers. As a writer, I write remembering the child I was, am still, will always be. That is what, through literature, I hope to bring to the children.

Jacqueline Woodson was born in Columbus, Ohio, and currently lives in Brooklyn, New York.

Bibliography

Last Summer with Maizon. Delacorte, 1990.

Martin Luther King, Jr., and His Birthday. Illustrated by Floyd Cooper. Silver, 1990.

The Dear One. Delacorte, 1991.

YARBROUGH, CAMILLE (1948–)
Author

Yarbrough—actress, composer, and singer—has appeared on television and in the theater in a number of roles. She was a member of the New York and touring companies of *To Be Young, Gifted and Black*. *The Iron Pot Cooker*, her recorded songs and dialogues, was favorably reviewed. She was awarded a Jazzy Folk Ethnic Performance Fellowship by the National Endowment for the Arts. She served as a guest hostess of "Night Talk" on radio station WWRL, New York, and lecturer at the First World Alliance Net Zion Lutheran Church in New York.

Among her awards are the Unity Award in Media from Lincoln University in 1982 and a "Woman of the Month" citation by *Essence* magazine in 1979. In 1975 she was named "Griot of the Year" by the Griot Society of New York.

Born in Chicago and now living in New York, Yarbrough is currently professor of African dance in the Black Studies Department of City College of New York. She also teaches at African Poetry Theatre, a writing workshop in Queens.

Bibliography

Cornrows. Illustrated by Carole Byard. Coward, 1979.

A Little Tree Growing in the Shade. Putnam, 1987.

The Shimmershine Queens. Putnam, 1989.

YOUNG, ANDREW STURGEON NASH [A.S. "DOC" YOUNG] (1924–)
Author

A.S. "Doc" Young obtained a bachelor's degree at Hampton Institute. He was a sports editor at the *Los Angeles Sentinel* and at *Ebony, Jet,* and *Hue* magazines. He was also managing editor of *Copper, Tan,* and *Jet* magazines and has been a radio commentator. His memberships include the Greater Los Angeles Press Club, Black Economic Union, Publicist Guild, Los Angeles Urban League, and the NAACP. Among his awards are the Los Angeles "Ghetto Award," President's Anniversary Sports Award, National Newspaper Publishers Association, and the American Library Association Award for Negro Firsts in Sports.

Bibliography

Black Champions of the Gridiron: Leroy Keys and O.J. Simpson. Harcourt, 1969.

The Mets from Mobile: Tommie Agee, Cleon Jones. Harcourt, 1970.

YOUNG, BERNICE ELIZABETH (1931–)
Author

The author was born in Cleveland. She was one of the first of six blacks to be accepted by Vassar College (1949–1951). Young has enjoyed writing since childhood and used her writing skills for the very popular music group, the Beatles, when she worked in advertising. Her other interests include music, ballet, and sports.

Bibliography

Harlem: The Story of A Changing Community. Messner, 1972.

The Picture Story of Hank Aaron. Messner, 1974.

The Picture Story of Frank Robinson. Messner, 1975.

YOUNG, MARGARET B. (1922–)
Author

Margaret B. Young majored in English at Kentucky State College and obtained a master's degree in educational psychology from the University of Minnesota. She is the widow of Whitney M. Young, Jr., former executive director of the National Urban League. She taught Dr. King's sister at Spelman College and his mother at Atlanta University.

Bibliography

First Book of American Negroes. Watts, 1966.

Picture Life of Martin Luther King, Jr. Watts, 1968.

APPENDIX I:
Awards and Honor Books

Coretta Scott King Award

The award is presented annually by the Coretta Scott King Task Force of the American Library Association's Social Responsibilities Round Table to a black author and/or illustrator whose books promote an understanding and appreciation of the cultures of all people and the contributions we all make to the realization of the "American dream." [Note that an asterisk (*) indicates a title not included in the bibliographies.]

1970—Author, Lillie Patterson. *Martin Luther King, Jr.: Man of Peace* (Garrard)

1971—Author, Charlemae Rollins. *Black Troubadour, Langston Hughes* (Rand McNally)

Honorable Mention:

Author, Maya Angelou. * *I Know Why the Caged Bird Sings* (Random)

Author, Shirley Chisolm. * *Unbought and Unbossed* (Houghton)

Author, Mari Evans. * *I Am a Black Woman* (Morrow)

Author, Lorenz Graham. * *Every Man Heart Lay Down* (Crowell)

Compilers, June Jordan & Terri Bush. *The Voice of the Children* (Holt)

Authors, Barney Grossman and Gladys Groom; illustrator, Charles Bible. *Black Means . . .* (Hill & Wang)

Author, Margaret Peters. * *The Ebony Book of Black Achievement* (Johnson)

1972—Author, Elton C. Fax. *Seventeen Black Artists* (Dodd, Mead)

1973—Author, Alfred Duckett. * *I Never Had It Made: The Autobiography of Jackie Robinson* (Putnam)

1974—Author, Sharon Bell Mathis; illustrator, George Ford. *Ray Charles* (Crowell)

Honorable Mention:

Author, Louise Crane. * *Ms Africa: Profiles of Modern African Women* (Lippincott)

Author, Alice Childress. *A Hero Ain't Nothin' but a Sandwich* (Coward)

Author, Lucille Clifton. *Don't You Remember?* Illustrated by Evaline Ness (Dutton)

Author, John Nagenda; *Mukasa.* Illustrated by Charles Lilly (Macmillan)

Author, Kristin Hunter. *Guests in the Promised Land* (Scribner)

1975—Author, Dorothy Robinson; Herbert Temple, illustrator. *The Legend of Africania* (Johnson)

1976—Author, Pearl Bailey. *Duey's Tale* (Harcourt, Brace & Jovanovich)

Honorable Mention:

Author, Shirley Graham. *Julius K. Nyerere: Teacher of Africa* (Messner)

Author, Walter Dean Myers. *Fast Sam, Cool Clyde and Stuff* (Viking)

Author, Mildred D. Taylor. *Song of the Trees* (Dial)

Author, Eloise Greenfield. *Paul Robeson.* Illustrated by George Ford (Crowell)

1977—Author, James Haskins. *The Story of Stevie Wonder* (Lothrop)

Honorable Mention:

Author, Lucille Clifton. *Everett Anderson's Friend.* Illustrated by Ann Grifalconi (Holt)

Authors, Clarence Blake and Donald Martin. * *Quiz Book on Black America* (Houghton)

Editors of Franklin Watts. *Encyclopedia of Africa* (Watts)

Author, Mildred D. Taylor. *Roll of Thunder, Hear My Cry* (Dial)

1978—Author, Eloise Greenfield; Carole Byard, illustrator. *Africa Dream* (John Day/Crowell)

Honorable Mention:

Author, James Haskins. *Barbara Jordan* (Dial)

Author, Lillie Patterson. *Coretta Scott King* (Garrard)

Author, William J. Faulkner. * *The Days When the*

Animals Talked: Black Folktales and How They Came to Be (Follett)

Author, Eloise Greenfield. *Mary McLeod Bethune* (Harper)

Author, Ruth A. Stewart. *Portia: The Life of Portia Washington Pittman, the Daughter of Booker T. Washington* (Doubleday)

Author, Frankcina Glass. * *Marvin and Tige* (St. Martin Press)

1979—Author, Ossie Davis. *Escape to Freedom: A Play about Young Frederick Douglass* (Viking)

Illustrator, Tom Feelings. *Something on My Mind.* Written by Nikki Grimes (Dial)

Honorable Mention:

Author, Carol Fenner. * *Skates of Uncle Remus* (Random House)

Author, Nikki Grimes; Tom Feelings, illustrator. *Something on My Mind* (Dial)

Author, Virginia Hamilton. *Justice and Her Brothers* (Greenwillow)

Author, Lillie Patterson. *Benjamin Banneker* (Abingdon)

Author, Jeanne Peterson. * *I Have a Sister, My Sister is Deaf* (Harper)

1980—Author, Walter Dean Myers. *The Young Landlords* (Viking)

Illustrator, Carole Byard. *Cornrows.* Written by Camille Yarbrough (Coward)

Honorable Mention:

Authors, Eloise Greenfield and Lessie Jones Little. *Childtimes: A Three-Generation Memoir* (Harper)

Author, Berry Gordy. * *Movin' Up* (Harper)

Author, James Haskins. *Andrew Young: Man with a Mission* (Lothrop)

Author, Ellease Southerland. * *Let the Lion Eat Straw* (Scribner)

Author, James Haskins. *James Van Der Zee: The Picture Takin' Man* (Dodd)

1981—Author, Sidney Poitier. * *This Life* (Knopf)

Author/Illustrator, Ashley Bryan. *Beat the Story Drum, Pum Pum* (Atheneum)

Honor:

Author, Alexis Deveaux. *Don't Explain: A Song of Billie Holiday* (Harper)

Illustrator, Carole Byard. *Grandmama's Joy.* Written by Eloise Greenfield (Philomel)

Illustrator, Jerry Pinkney. *Count On Your Fingers: African Style* written by Claudia Zaslavsky (Crowell)

1982—Author, Mildred Taylor. *Let the Circle Be Unbroken* (Dial)

Illustrator, John Steptoe. *Mother Crocodile.* Written by Birago Diop; translated and adapted by Rosa Guy (Delacorte)

Honor:

Author, Alice Childress. *Rainbow Jordan* (Coward, McCann & Geoghegan)

Author, Kristin Hunter. *Lou in the Limelight* (Scribner)

Author, Mary E. Mebane. * *Mary* (Viking)

Illustrator, Tom Feelings. *Daydreamers.* Writtenby Eloise Greenfield (Dial)

1983—Author, Virginia Hamilton. *Sweet Whispers, Brother Rush* (Philomel)

Illustrator, Peter Magubane. *Black Child* (Knopf)

Honor:

Author, Julius Lester. *This Strange New Feeling* (Dial)

Author/Illustrator, Ashley Bryan. *I'm Going to Sing: Black American Spirituals, Vol. II* (Atheneum)

Illustrator, Pat Cummings. *Just Us Women.* Written by Jeannette Caines (Harper)

Illustrator, John Steptoe. *All the Colors of the Race.* Written by Arnold Adoff (Morrow)

1984—Author, Lucille Clifton. *Everett Anderson's Goodbye* (Holt)

Illustrator, Pat Cummings. *My Mama Needs Me.* Written by Mildred Pitts Walter (Lothrop)

Special Citation to Coretta Scott King for * *The Words of Martin Luther King, Jr.* (Newmarket)

Honor:

Author, Virginia Hamilton. *The Magical Adventures of Pretty Pearl* (Harper).

Author, James Haskins. *Lena Horne* (Coward)

Author, Joyce Carol Thomas. *Bright Shadow* (Avon)

Author, Mildred Pitts Walter. *Because We Are* (Lothrop)

1985—Author, Walter Dean Myers. *Motown and Didi* (Viking)

Honor:

Author, Virginia Hamilton. *Little Love* (Philomel)

Author, Candy Dawson Boyd. *The Circle of Gold* (Apple/Scholastic)

1986—Author, Virginia Hamilton. *The People Could Fly: American Black Folktales* (Knopf)

Illustrator, Jerry Pinkney. *The Patchwork Quilt* written by Valerie Flournoy (Dial)

Honor:

Author, Virginia Hamilton. *Junius Over Far* (Harper)

Author, Mildred Pitts Walter. *Trouble's Child* (Lothrop)

Illustrators, Leo and Diane Dillon. *The People Could Fly* written by Virginia Hamilton (Knopf)

1987—Author, Mildred Pitts Walter. *Justin and the Best Biscuits in the World* (Lothrop)

Illustrator, Jerry Pinkney. *Half a Moon and One Whole Star.* Written by Crescent Dragonwagon (Macmillan)

Honor:

Author/Illustrator, Ashley Bryan, *Lion and the Ostrich Chicks and Other African Tales* (Atheneum)

Author, Joyce Hansen. *Which Way Freedom?* (Walker)

Illustrator, Pat Cummings. *C.L.O.U.D.S.* (Lothrop)

1988—Author, Mildred D. Taylor. *The Friendship* (Dial)

Illustrator, John Steptoe. *Mufaro's Beautiful Daughters: An African Tale.* (Lothrop)

Honor:

Author, Alexis DeVeaux. *An Enchanted Hair Tale* (Harper)

Author, Julius Lester. *The Tales of Uncle Remus: The Adventures of Brer Rabbit* (Dial)

Author/Illustrator, Ashley Bryan. *What a Morning! The Christmas Story in Black Spirituals.* Selection by John Langstaff (A Margaret McElderry Book)

Author, Joe Sam. *The Invisible Hunters: A Legend from the Miskito Indians of Nicaragua.* Compiled by Harriet Rohmer, et al. (Children's Book Press)

1989—Walter Dean Myers. *Fallen Angels.* (Scholastic)
 Illustrator, Jerry Pinkney. *Mirandy and Brother Wind.*
 Written by Patricia C. McKissack (Knopf)
Honor:
 Author, James Berry. *A Thief in the Village and Other Stories* (Orchard)
 Author, Virginia Hamilton. *Anthony Burns: The Defeat and Triumph of a Fugitive Slave* (Knopf)
 Illustrator, Amos Ferguson. *Under the Sunday Tree.* Written by Eloise Greenfield (Harper)
 Illustrator, Pat Cummings. *Storm in the Night.* Written by Mary Stolz (Harper)
1990—Authors, Patricia and Fredrick McKissack. *A Long Hard Journey . . .* (Walker)
 Illustrator, Jan Spivey Gilchrist. *Nathaniel Talking.* Written by Eloise Greenfield (Black Butterfly)
Honor:
 Author, Eloise Greenfield. *Nathaniel Talking* (Black Butterfly)
 Author, Virginia Hamilton. *The Bells of Christmas* (Harcourt)
 Author, Lillie Patterson. *Martin Luther King, Jr. and the Freedom Movement* (Facts on File)
 Illustrator, Jerry Pinkney. *The Talking Eggs.* Written by Robert San Souci (Dial)
1991—Author, Mildred D. Taylor. *The Road to Memphis* (Dial)
 Illustrators, Leo and Diane Dillon. *Aida.* Retold by Leontyne Price (Gulliver/HBJ)
Honor:
 Author, James Haskins. *Black Dance in America* (Harper/Collins)
 Author, Angela Johnson. *When I Am Old with You.* Illustrated by David Soman (Orchard)

Newbery Medal Awards and Honor Books

The John Newbery medal is awarded for the book that represents the most distinguished contribution to children's literature published in the preceding year.

1969—Honor Book: *To Be A Slave* by Julius Lester (Dial)

1972—Honor Book: *The Planet of Junior Brown* by Virginia Hamilton (Macmillan)

1975—Winner: *M.C. Higgins the Great* by Virginia Hamilton (Macmillan)

1976—Honor Book: *The Hundred Penny Box* by Sharon Bell Mathis (Viking)

1977—Winner: *Roll of Thunder, Hear My Cry* by Mildred D. Taylor (Dial)

1983—Honor Book: *Sweet Whispers, Brother Rush* by Virginia Hamilton (Philomel)

1989—Honor Book: *In the Beginning: Creation Stories from Around the World* by Virginia Hamilton (Harcourt, Brace Jovanovich)
Honor Book: *Scorpions* by Walter Dean Myers (Harper)

Randolph Caldecott Medal and Honor Books

The Randolph Caldecott Medal is given to the most distinguished picture book published the previous year.

1972—Honor Book: *Moja Means One* words by Muriel Feelings, illustrations by Tom Feelings. (Dial)

1975—Honor Book: *Jambo Means Hello* words by Muriel Feelings, illustrations by Tom Feelings. (Dial)

1976—Winner: *Why Mosquitoes Buzz in People's Ears*, as retold by Verna Aardema, illustrations by Leo and Diane Dillon. (Dial)

1977—Winner: *Ashanti to Zulu: African Traditions*, words by Margaret Musgrove, illustrations by Leo and Diane Dillon (Dial)

1979—Honor Book: *Freight Train*, words by Donald Crews (Greenwillow)

1981—Honor Book: *Truck*, words by Donald Crews (Greenwillow)

1985—Honor Book: *The Story of Jumping Mouse*, retold and Illustrated by John Steptoe (Lothrop, Lee and Shepard)

1988—Honor Book: *Mufaro's Beautiful Daughters*, retold and Illustrated by John Steptoe (Lothrop, Lee and Shepard)

1989—Honor Book: *Mirandy and Brother Wind*, words by Patricia C. McKissack, illustrations by Jerry Pinkney (Knopf/Random House)

1990—Honor Book: *The Talking Eggs*, words by Robert San Souci, Illustrations by Jerry Pinkney (Dial)

Boston Globe–Horn Book Award

This award is presented annually by the Horn Book Magazine and the *Boston Globe* for outstanding fiction, nonfiction, and illustration.

1974—Fiction: *M.C. Higgins the Great* by Virginia Hamilton (Macmillan)
Illustration: *Jambo Means Hello* by Muriel Feelings, Illustrated by Tom Feelings (Dial)

1983—Fiction: *Sweet Whispers, Brother Rush* by Virginia Hamilton (Philomel)

1987—Illustration: *Mufaro's Beautiful Daughters* by John Steptoe (Lothrop, Lee & Shepard)

1988—Fiction—*The Friendship* by Mildred D. Taylor (Dial)
Nonfiction—*Anthony Burns: The Defeat and Triumph of a Fugitive Slave* by Virginia Hamilton (Knopf)

APPENDIX II:
Publishers' Series

Black Butterfly Children's
Books/Writers and Readers
Publishing, Inc. (West Dist.)
P.O. Box 461 Village Station
New York, NY 10014
Board books written by
Eloise Greenfield and
illustrated by Jan Spivey
Gilchrist. Includes *I Make
Music, My Daddy and I, Big
Friend, Little Friend, My Doll
Keshia.*

Chelsea House Publishers
95 Madison Avenue
New York, NY 10016
*Black Americans of Achieve-
ment*: Includes: *Sojourner
Truth, Malcolm X, Thurgood
Marshall*

Children's Press
5440 North Cumberland
Avenue
Chicago, Illinois 60656
Rookie Readers. Includes:
Messy Bessey readers by
Patricia and Fredrick
McKissack
Picture Story Biographies.
Includes: *James Weldon
Johnson: Lift Every Voice and
Sing* by Patricia & Fredrick
McKissack

Enslow Publishers, Inc.
Bloy Street & Ramsey
Avenue
Box 777
Hillside, NJ 07205
Great African Americans.
Includes: *Ralph J. Bunche:
Peacemaker, Ida B. Wells-
Barnett: Voice Against Vio-
lence* and more

Just Us Books
301 Main Street
Orange, NJ 07050
The Afro-Bets: Fiction and
non-fiction with the same
family characters: *Afro-Bets
Book of Black Heroes, Afro-
Bets A B C Book, Afro-Bets 1
2 3 Book* and more

Silver Burdett
P.O. Box 1226
Westwood, NJ 07675-1226
*Reflections of a Black Cow-
boy; Cowboys and Soldiers* by
Robert Miller (Paperbacks)
The History of the Civil War.
Ten biographies in the
series.

Twenty-First Century Books
African-American Military Leaders. Includes profiles of Colin Powell, Benjamin Davis, Jr., and "Chappie" James

Ward Hill Press
40 Willis Avenue
Staten Island, NY 10301
Unsung Americans (Paper Back Series): *Zora Neale Hurston: A Storyteller's Life,* written by Janelle Yates and Illustrated by David Adams.

Franklin Watts
387 Park Avenue South
New York, NY 10016
Impact Biography Series. Includes: *W.E.B. Du Bois* by Patricia and Fredrick McKissack

Appendix III:
Publishers

A.S.C. Publishing
1342 West Martin Luther
King Jr. Boulevard
Los Angeles, CA 90037
Asante Publications
P.O. Box 19864
San Diego, CA 92120

Associated Publishers
1401 14th Street NW
Washington, D.C. 20005
The Black Scholar Press
P.O. Box 7106
San Francisco, CA 94120

Black Butterfly Press/Writers
and Readers Publishing, Inc.
P.O. Box 461
Williams Street
New York, NY 10014

Charill Publications
44–68 San Francisco Avenue
St. Louis, MO 63115

Creative Ideas Publishing
Company
P.O. Box 7208
Newark, NJ 07107
Dusable Museum of African
American History Press
740 East 56th Place
Chicago, IL 60611

Garrett Park Press
P.O. Box 37467
Washington, D.C. 20013

Gumbs & Thomas Publish-
ers
2067 Broadway
Suite 41
New York, NY 10023

Johnson Publishing Com-
pany
1820 South Michigan
Avenue
Chicago, IL 60605

Just Us Books
301 Main Street
Suite 22–24
Orange, NJ 07050

Marcus Garvey Publishing
Company
1 World Trade Center
Suite 8817
New York, NY 10048

Open Hand Publishers, Inc.
P.O. Box 22048
Seattle, WA 98122

Path Press, Inc.
53 W. Jackson Boulevard
Suite 1040
Chicago, IL 60604

The Red Sea Press, Inc.
15 Industrial Court
Trenton, NJ 08638

Telkee Press
126 Lexington Avenue
Suite 201
New York, NY 10016

Third World Press
7524–26 South Cottage
Grove Avenue
Chicago, IL 60619–1999

UCLA Center for Afro-
American Studies
405 Hillgard Avenue
3111 Campbell Hall
Los Angeles, CA 90034

Appendix IV:
Bookstores and Distributors

Know Thyself Bookstore
808 6th Street North
Birmingham, AL 35202

F.E. Distributors
P.O. Box 2467
Tucson, AZ 85702-2467

Afro-American Resource
Center
240 W. Compton Boulevard
Compton, CA 90220

Human Resources
P.O. Box 2722773
Concord, CA 94527

Marcus Books
3900 Grove Street
Oakland, CA 94609

Pathfinder Bookstore
3702 Telegraph Avenue
Oakland, CA 94009

Oasis Black World Books
10–10B Florin Road
Sacramento, CA 95831

Marcus Books
1712 Fillmore
San Francisco, CA 94114

The Hue-Man Experience
911 23rd Street
Denver, CO 80205

Common Concerns Inc.
1347 Connecticut Avenue
Washington, D.C. 20036

Pyramid Bookstore
2849 Georgia Avenue NW
Washington, D.C. 20001

Ujamaa Bookstore
1554 8th Street NW
Washington, D.C. 20001

Afro–In Books N'Things
5575 NW 7th Avenue
Miami, FL 33127

Charles Whitehead
P.O. Box 50541
Atlanta, GA 30302

E.N. Kikuyu Green
32 Greenbriar Drive
Savannah, GA 31406

Honolulu Book Shops, Ltd.
287 Kaliki Street
Honolulu, HA 96819

The Book Shelf
10390 Overland Road
Boise, ID 83709

African American Bookstore
7524–26 Cottage Grove
Avenue
Chicago, IL 60619

African-Caribbean Trade
Bureau
6829 S. Constance Avenue
Chicago, IL 60649

Afro-Am Inc.
819 S. Wabash Avenue
Suite 610
Chicago, IL 60605

Akbar's Books and Things
12156 S. Princeton
Chicago, IL 60628

Dusable Museum Gift Shop
740 E. 56th Place
Chicago, IL 60637

Ebony Book Shelf
P.O. Box 538
Chicago, IL 80690

Twenty-First Century Books
P. O. Box 803351
Chicago, IL 60680

East St. Louis Book Store
P. O. Box 744
East St. Louis, IL 62201

MWA Africa
3749 Guilford Avenue
Indianapolis, IN 46205

Cultural Expression
1008 State Avenue
Kansas City, KS 66102

Nubian Bookstore
2109 W. Broadway
Louisville, KY 40211

Community Book Center
1200 Ursulines
New Orleans, LA 70116

Everyone's Place
1380 W. North Avenue
Baltimore, MD 21217

The Tape Connection
3013 W. North Avenue
Baltimore, MD 21213

Afro-American Literature
Service
5430 Flynx Lane
Columbia, MD 21044

African-American Book
Store
P.O. Box 851
Boston, MA 02120

Eric Brown
59 Whales Street
Boston, MA 02124

Babatunde Bandeleh
17608 Santa Rosa
Detroit, MI 48221

Detroit Books & Things
1605 West Davidson
Detroit, MI 48232

Utopia Enterprises
17585 Greenhorn Street
Detroit, MI 58221

The Book End
P.O. Box 609
Franklin, MI 48025

Crescent Imports and
Publications
3066 Carpenter
Ypsilanti, MI 48197

Uhuru Books
3821 Clinton Avenue, #2
Minneapolis, MN 55411

Culturally Speaking
1601 E. 18th Street
Kansas City, MO 64108

Akbar's Books and Things
8816 Manchester
Suite 117
St. Louis, MO 63144

Century 21 African Ameri-
can Books and Educational
Materials
4529 Greer Avenue
St. Louis, MO 63115

Adhiambo Bookstore
703 Hooker Street
Jackson, MS 39204
The Book Store
263 Central Avenue
East Orange, NJ 07018

The Black Book Club
P.O. Box 40
Fanwood, NJ 07023

Baby Boomers Books
1102 Washington Street
Hoboken, NJ 07030

All African People's Books
P.O. Box 4036
Newark, NJ 07114

Kwane O. Jwyanza
416 Livingston Avenue
New Brunswick, NJ 08901

The Black Book Connection
P.O. Box 706
Nutley, NJ 07110

Shabazz Books & Things
393 Monroe Street
Passaic, NJ 07090

Bridges Book Store
1480 Main Street
Rahway, NJ 07065

Marcus Garvey Books
162 Northampton
Willingboro, NJ 08046

Belfield's Book Store
501 Lefferts Avenue
Suite 5H
Brooklyn, NY 11225

D.A. Reid Enterprises
(D.A.R.E.)
33 Lafayette Avenue
Brooklyn, NY 11205

Headstart Books and Crafts
604 Flatbush Avenue
Brooklyn, NY 11225

Nkiru International Books
66 St. Marks Avenue
Brooklyn, NY 11217

Harambee Books
31 St. Paul Mall
Buffalo, NY 14209

Warner Bookstore
114–36 Francis Lewis Blvd.
Cambria Heights, NY
11411

Triangle Bookstore
403 College Avenue
Ithaca, NY 14850

Afrika House
2030 Fifth Avenue
New York, NY 10035

Benjamin Books Inc.
World Trade Center
New York, NY 10048

Black Books Plus
702 Amsterdam Avenue
New York, NY 10025

Liberation Bookstore
421 Lenox Avenue
New York, NY 10037

Pickney Productions
1123 Broadway Suite 805
New York, NY 10010

Positive Images Bookstore
172-44 133rd Avenue
Rochdale Village, NY 11434

The Studio Museum of
Harlem
144 W. 125th Street
New York, NY 10027

The Unity Cultural Shop
c/o John Ogle
927 Midland Avenue
Syracuse, NY 13205

Lateef Imports
311 Dobbs Street
Hertford, NC 27944

Freedom Bookstore
P.O. Box 26744
Raleigh, NC 27611

Ebony Book Store
4006 Princess Place Dr.
Wilmington, NC 28405

New Horizons Book Club
1405 East 3rd Street
Winston-Salem, NC 27101

Student Book Exchange
1606 North High Street
Columbus, OH 43201

Showcase Books
145 W. Market Street
Warren, OH 44481

Black Heritage Center
Langston University
P.O. Box 967
Langston, OK 73050

Talking Drum Bookstore
1640 NE Alberta
Portland, OR 97211

Afro-American Cultural and
Historical Museum
7th & Arch Streets
Philadelphia, PA 19108

Robin's Book Store
1837 Chestnut Street
Philadelphia, PA 19108

The Black Action Society
William Pitt Union,
Room 627
University of Pittsburgh
Pittsburgh, PA 15260

Cornerstone Books
P.O. Box 2591
Providence, RI 02906

Heritage Book Center
c/o Willie E. Mayo
1019 Kismet Drive
Aiken, SC 29801

Epic Books and
Information Center
4638 Bonnie Forest
Boulevard
Columbia, SC 29210

Book World
499 Merrit Avenue
Nashville, TN 37203

Johnson Books
6380 Phelan
Beaumont, TX 77706

Black Images Book Co.
1322 Woodburn Trail
Dallas, TX 75241

Afro-American Book
Distributors
2537 Prospect
Houston, TX 77004

Amistad Book Place
1413 Holman
Houston, TX 77084

Liberation Books
117 Hume Avenue
Alexandria, VA 22301

The Book Stop
1903–B Lafayette Boulevard
Norfolk, VA 23509

Self-Improvement
Educational Center
604 West 35th Street
Norfolk, VA 23508

African Arts
118 W. Brookland Park
Boulevard
Richmond, VA 23222

African Institute of Learning
4800 South Frontenac
Seattle, WA 96118

Karimu Bookstore
812 Lake Washington
Boulevard, South
Seattle, WA 98144

Positive Image Books &
Gifts
3808 West Burleigh Street
Milwaukee, WI 53210

Major's Bookstore
221 Hald Street
Charles Town, WV 25301

Index of Children's Book Titles